MAIDSTONE
From Old Photographs

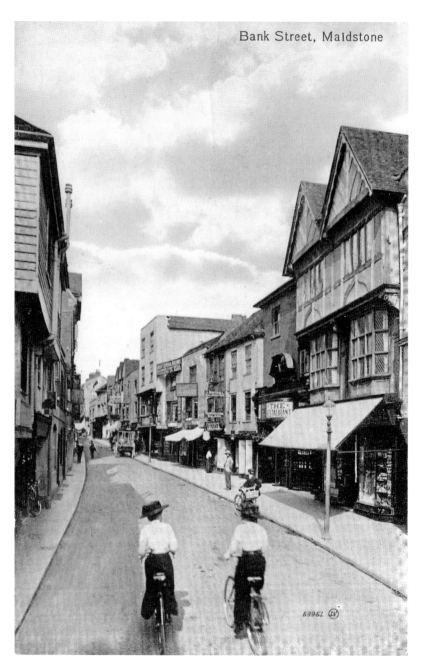

Bank Street, Maidstone

BANK STREET in 1912.

MAIDSTONE

From Old Photographs

IRENE HALES

AMBERLEY

First published by Alan Sutton Publishing Limited, 1990
This edition published 2009

Copyright © Irene Hales 2009

Amberley Publishing
Cirencester Road, Chalford,
Stroud, Gloucestershire, GL6 8PE

British Library Cataloguing in Publication Data.
A catalogue record for this book is available from the British Library.

ISBN 978-1-84868-556-7

Typesetting and origination by Amberley Publishing
Printed in Great Britain

CONTENTS

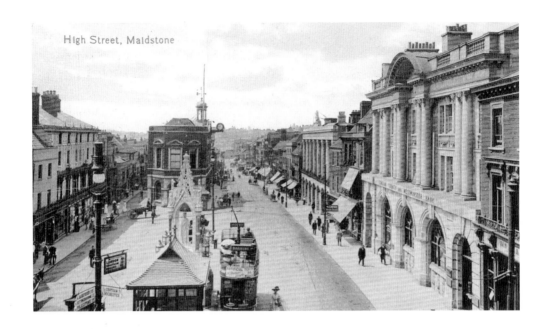
High Street, Maidstone

INTRODUCTION

Maidstone, the county town and administrative centre of Kent, is situated on the River Medway and its tributary the Len, almost midway between London and Dover. It is the natural centre of one of England's richest agricultural areas, which includes the fertile Medway valley and part of the Weald of Kent. The town is surrounded by many picturesque villages, each of which is full of antiquity and interest. The ridge of the North Downs lies three miles to the north-east of Maidstone and along its southern slope is the ancient track known as the Pilgrim's Way. Megalithic remains in this area include the famous Kit's Coty House and the Countless Stones.

During Roman occupation of the Maidstone area there was a scattered farming community with villas near the sites now occupied by the Grammar School for Boys, Maidstone East Station, Little Buckland and Allington Castle. The Roman road from Rochester to the south entered the town along roughly the same route as the present Maidstone to Chatham road, by way of Bluebell Hill, along Week Street and Stone Street. Despite the Roman occupation of the area, there is no record of Maidstone having a Roman name. It appears that the name of Maidstone has evolved from the Anglo-Saxon Medwegestun or Maegwanstane.

In Anglo-Saxon times Maidstone was little more than a hamlet grouped around the Church of St Mary (the present All Saints') and belonged to the Archbishop of Canterbury. At that time, Penenden Heath, a common situated about a mile to the north-east of Maidstone, was the official meeting place for the Shire and the place where the first County Courts were held. From long before the Norman invasion until the year 1830 criminals convicted of capital offences were hanged on the Heath.

The Norman Domesday Survey provides positive information about Maidstone. The town consisted of about a hundred houses, all included in the Archbishop's demesne. There was a medium-sized manor with an area of approximately 1,500 acres, two saltworks, fisheries and several mills.

By medieval times Maidstone was dominated by the Church but derived considerable advantages from the patronage and presence of the Archbishops. In 1260 Archbishop Boniface founded a hospital for pilgrims called The Newark, dedicated to St Peter and St Paul, in Westborough. The Newark was possibly a kind of bridge chapel and resting place for travellers on their way to Canterbury. In 1261 Boniface was granted permission by King Henry III to hold a weekly market at Petrisfield, which was possibly the churchyard connected with The Newark. The establishment of this market must have accrued substantial advantages to the town as today, seven centuries later, Maidstone is still a flourishing market town.

In 1395 Archbishop Courtenay received authority from Rome to make the parish church collegiate. Not only was a college erected for a Master and twenty-four chaplains and clerks, but the church itself was completely rebuilt. The adjacent Manor House was also reconstructed in the foureenth century by Archbishops Ufford and Islip and became known as the Archbishop's Palace. The stable building east of the church and the first stone bridge over the Medway, consisting of nine arches, are also attributed to the Archbishops.

It was mainly due to this religious domination of the town that Maidstone played a prominent role in rebellions. The townsmen, however well they traded or prospered were oppressed under the ecclesiastical yoke. The Peasants Revolt of 1381 rallied on Penenden Heath and the leader, Wat Tyler (a native of Maidstone) with his supporters, rescued John Ball, the 'Mad Priest of Kent', from Archbishop Sudbury's prison (believed to be the dungeons next to the Archbishop's Palace). Tyler's Lane (now called Union Street) was named after Wat Tyler. In 1450 Jack Cade drew his followers together on the Heath to rebel against heavy taxation, court corruption and the government's incompetent domestic and foreign policies. Three of Cade's followers, Richard Culpeper, William Beale and John Fisher, were members of well-known Maidstone families.

The Protestant King Edward VI gave Maidstone its first Charter of Incorporation in 1549 and Richard Healey was appointed the first Mayor of Maidstone. Five years later, Sir Thomas Wyatt (the Younger) of Allington Castle led a rebellion against the marriage of Queen Mary and Philip of Spain and as a result Wyatt lost his head and Maidstone its Charter. Queen Elizabeth granted the town a new Charter in 1559. In all Maidstone has been granted six charters, of which two have been forfeited. By the beginning of the seventeenth century Maidstone was primarily a port and the centre of one of the largest industries in the south-east, that of quarrying and shipping ragstone. Local ragstone had been used for the building of many great edifices including the Tower of London and Westminster Palace and was used for the fortifications of Calais. The stone was also made into shot for cannons. Other local industries included the shipping of sand for the early flint-glass industry in London, gault clay for bricks and timber for the dockyard

at Chatham. Brewing was one of the town's staple industries and continued through to the 1970s.

Cloth-making was another important industry, introduced by Dutch refugees who had settled in Maidstone in the sixteenth century and who also brought with them the trades of flax-weaving, dyeing and linen thread-making. The discovery of veins of fuller's earth in the locality led to fulling mills for cleansing the cloth being set up on the River Len and the Loose Stream. When the cloth trade declined towards the end of the seventeenth century, the mills were converted to papermaking, still an important industry in Maidstone.

By the seventeenth century Kent was already known as The Garden of England and fruit, vegetables, hops and wheat were transported from Maidstone, largely by river, to London. By 1662 Maidstone had become important enough to be rated as one of the thirty-five most prosperous towns in the country.

It was during this period of prosperity that the town was caught up in the Civil War. On 1 June 1648 the Parliamentary troops, led by General Lord Fairfax, defeated the Royalist force in the streets of Maidstone. The victory was rated so highly by Parliament that it ordered a service of thanksgiving in the parish churches of London and Westminster. In January 1649, the death sentence passed on Charles I was read by Andrew Broughton, Clerk of the High Court of Justice, who was also Maidstone's Roundhead Mayor.

Maidstone's communications were greatly improved in the eighteenth century by the deepening of the channel of the Medway and the construction of locks and towpaths. Transport by road was improved, but it was the arrival of the railway in 1844 that further contributed to the town's prosperity.

The period covered by the photographs and postcards in this book – from about 1860 to the Second World War – witness the further expansion of Maidstone, its later industries, the arrival and subsequent disappearance of the trams, the advent of the trolleybus and electric theatre and its wide variety of buildings and shops. Also captured for posterity are public events, celebrations, fires and floods. The population during this period grew from 23,000 in 1860 to approximately 50,000 in 1943.

Today Maidstone is a diverse and important borough which, since 1974, has taken thirty-eight parishes inside its borders. It covers an area of 152 square miles and has a population of approximately 130,000.

Many of the companies which were household names in Maidstone have disappeared from the scene or been merged into some greater conglomerate. Tilling-Stevens, Foster Clark, Edward Sharp & Co., Style & Winch; these and many others have gone the way of so many well-known firms and the retail outlets have also changed beyond recognition. However, some of the old names remain and despite the modern style of shop front, which is now commonplace, one has only to look up at the roofs and upper stories of many of the buildings to be reminded of the town as it used to be.

The Archbishop's Precincts

The group of buildings in Mill Street and College Road, comprising All Saints' Church, the Archbishop's Palace, the Dungeons and the College of Priests, are a constant reminder of the powerful ecclesiastical dominance that once prevailed in Maidstone.

The ancient collegiate foundation of All Saints', comprising the Church and College, came to an end in the reign of Edward VI; the church became a parish church and the college was dissolved.

The Parish Church of All Saints', restored in 1886, is one of the finest and largest examples of a Perpendicular church in England; its only major loss has been the spire, struck by lightning in 1730.

The college property passed into private hands after the Dissolution and gradually fell into decay. In 1949 the remaining buildings were purchased for the town by Sir Garrard Tyrwhitt-Drake and later restored.

The Archbishop's Palace and Dungeons, also privately owned for centuries, were purchased by subscription for the town in 1887 to commemorate Queen Victoria's Golden Jubilee.

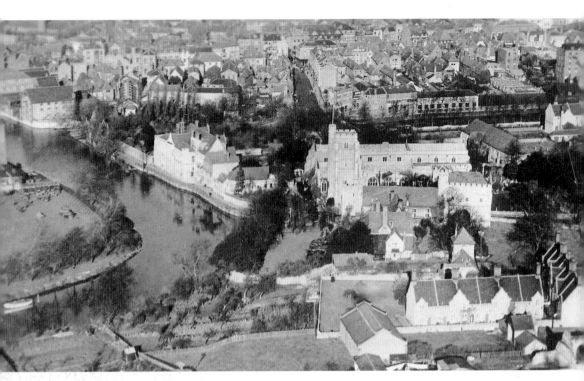

AN AERIAL VIEW OF THE ARCHBISHOP'S PRECINCTS on the River Medway, photographed *c.* 1930. The rear of the palace overlooks the Medway and All Saints' Church is in the centre of the group of buildings. The northern section of Mill Street can be seen above the church. Lock Meadow, to the west, now the site of Maidstone market, was formerly the Archbishop's Park, reached by a ford from the church. During the early years of the twentieth century a ferry operated from the slipway by the church to Lock Meadow, facilitating travel to the market; the fare was one halfpenny return.

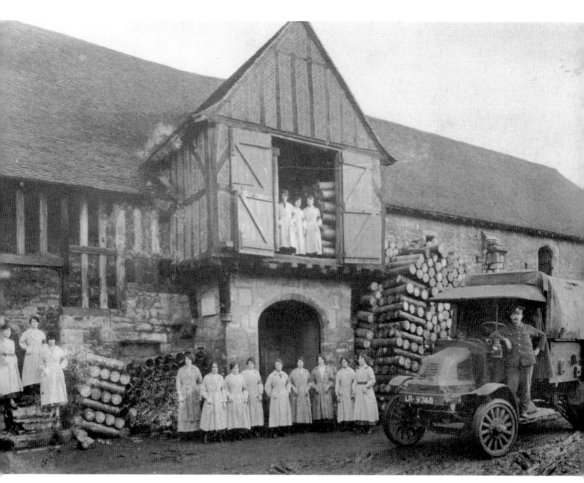

THE ARCHBISHOP'S STABLE BLOCK IN MILL STREET in 1917, after being requisitioned by the government for munitions work. This building was built about the same time as All Saints' Church (1397). The upper floor probably accomodated the Archbishop of Canterbury's servants when he stayed at his Maidstone palace, and the horses would have been stabled on the ground floor. The building was part of Dorman's Mill Street Tannery for many years and was purchased for the town by public subscription in 1913. Since November 1946 the stable block has housed a unique collection of carriages.

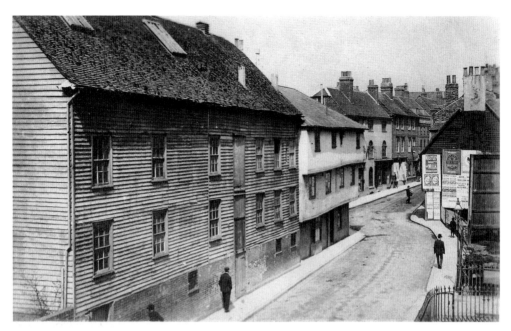

CHURCH MILL, photographed in 1880, was in existence at the time of Archbishop Courtenay (1395). It was one of two flour mills situated on the River Len in Mill Street.

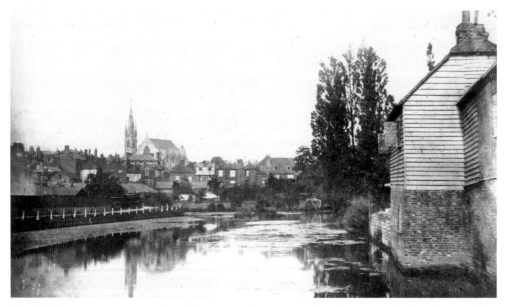

THE SECOND MILL was sited at what is now the junction of Mill Street and Palace Avenue. This view, looking along the River Len Pond from Mill Street in 1860, shows the old mill buildings and King Street Congregational and Baptist Church. The two mills were demolished when Mill Street was widened in 1903. The church, which was built on the site of the eighteenth-century King Street Prison, was demolished in the 1970s to make way for the Stoneborough Centre, now renamed the Chequers Centre.

SECTION TWO

The Medway

Maidstone has been fortunate in being situated on the River Medway, as for centuries the river was the town's main means of transport. By the nineteenth century small industries had mushroomed along its banks and the river trade had increased considerably.

There were several wharves in Maidstone, situated mainly near the bridge, and by 1834 between fifty and sixty barges were trading from the town. The advent of the steam train in 1844 did not severely affect river traffic; it was only when the road transport industry expanded significantly that the river trade declined. Gradually the barges disappeared, then one by one the industries vanished too.

Maidstone's three-arched bridge was built to replace the medieval bridge across the Medway. It was opened in August 1879 and widened in 1927.

Three more bridges were constructed over the Medway in the nineteenth century: these were the High Level Bridge which conveyed the Maidstone East railway line (part of the former London, Chatham and Dover Railway System); Tovil rail bridge, constructed by the South Eastern Railway Company to carry a short branch line to a goods station at Tovil, and Tovil footbridge to give access to the Tovil Paper Mills.

Maidstone's second town bridge was opened by HRH the Duke ofKent on 23 November 1978.

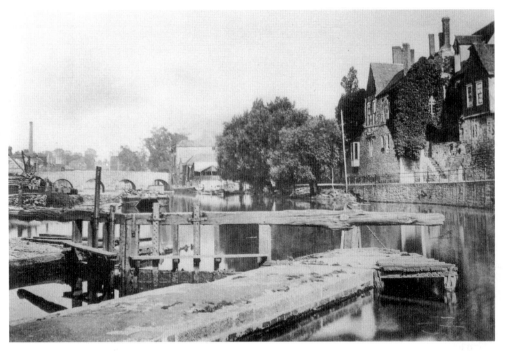

MAIDSTONE'S MEDIEVAL STONE BRIDGE over the River Medway, photographed in 1877, with College Lock in the foreground. The bridge was demolished after the opening of the new Maidstone Bridge in August 1879 and the stone removed in lighters to Burham, where it was used in the construction of cottages. College Lock was dismantled in 1882.

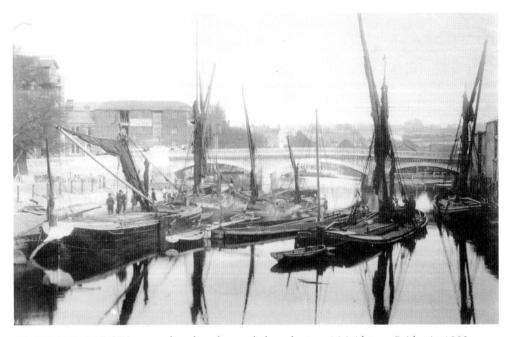

BOATS AND BARGES moored at the wharves below the 'new' Maidstone Bridge in 1882.

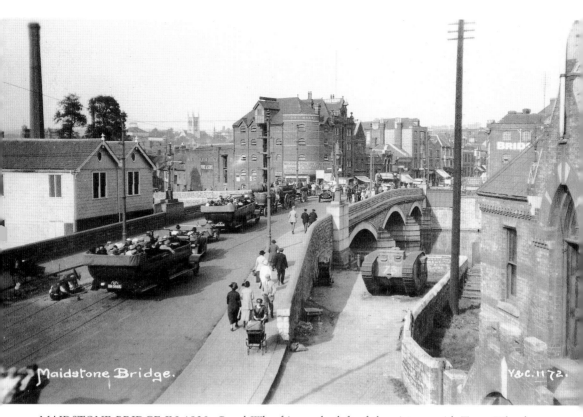

MAIDSTONE BRIDGE IN 1920. Canal Wharf is on the left of the picture, with Town Wharf and Bridge Wharf on the far side of the bridge. The large chimney visible behind Canal Wharf belonged to the Electricity Works. Note the early charabancs and the town's First World War tank in the position which it occupied before the widening of the bridge.

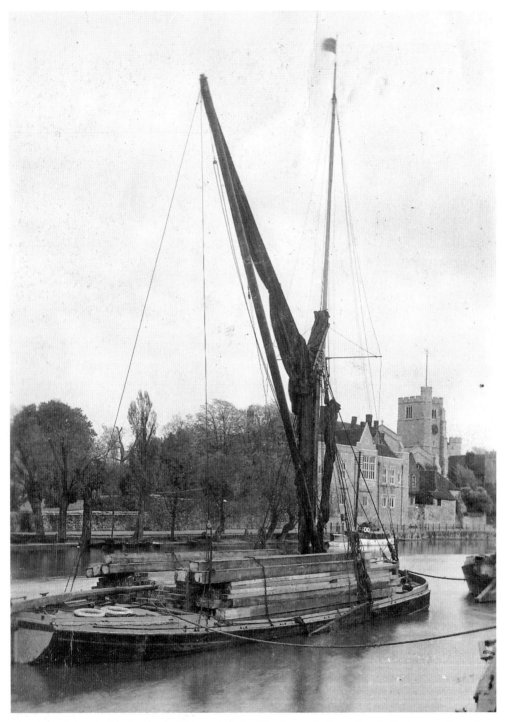

TIMBER BEING TRANSPORTED BY BARGE from Robert Batcheller's wood-yard at Westborough Wharf, the Broadway, in 1913.

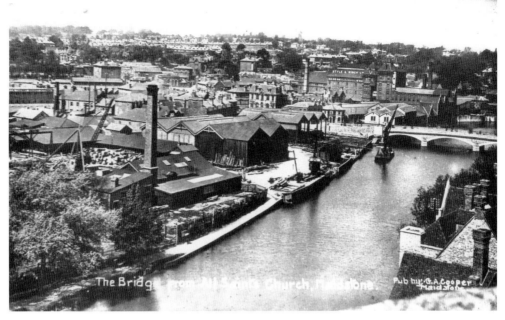

SMALL INDUSTRIES LINED THE WEST BANK OF THE MEDWAY in 1916. The new County Court and the Ferryman Inn have since taken their place.

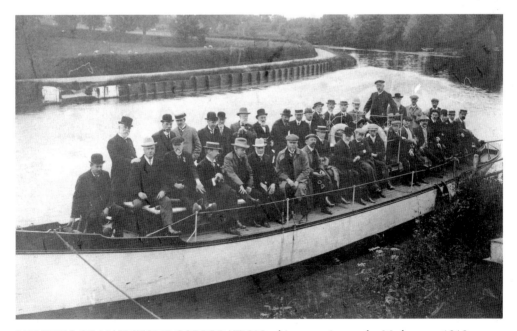

MEMBERS OF MAIDSTONE CORPORATION taking a cruise on the Medway, *c.* 1910.

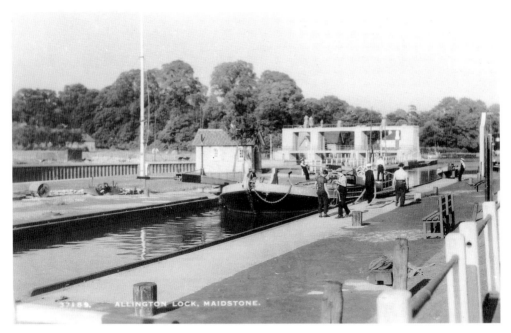

THE TEISE PASSING THROUGH ALLINGTON LOCK in 1938. The tidal sluices were completed in August 1937 to help alleviate the flood problem which had always been a threat to Maidstone.

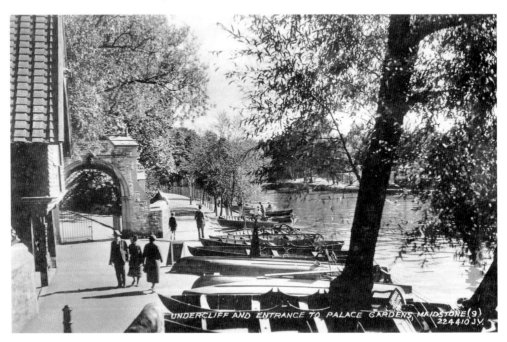

THIS RIVERSIDE SCENE taken in 1930 shows the entrance to Palace Gardens and Avery's boats and boat-house.

SECTION THREE

Streets

With the decline in the influence of the Church the focal point of the town shifted to the market-place at the top of the High Street known as High Town. The 'one longe streete' mentioned by the antiquary, Leland, in 1538 consisted of Week Street, Gabriel's Hill and Stone Street. The names of Week and Stone were derived from two of the ancient boroughs (Wyke, Stone, Maidstone and Westree), the last known to this day as Westborough. The earliest mention of Gabriel's Hill is in a fifteenth-century document.

Other ancient streets have been known by various names at different times. Mill Street was formerly Mill Lane and Earl Street was once called Earl's Lane. It was renamed Bullock Lane when livestock were penned there for the stockmarket. Middle Row and Pudding Lane date back to the fifteenth century, while the name of King Street is comparatively modern, given to East Lane after George III's visit to the town in August 1799.

Faith Street has become St Faith's Street and King's Mead, a tract of grassland given to the town by Edward VI, is now the busy Fairmeadow.

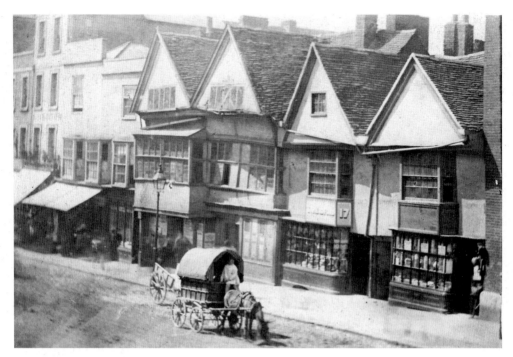

THE HIGH STREET, photographed in 1860, showing four fifteenth-century houses located between Pudding Lane and the Royal Star Hotel. The two on the left were demolished in 1862, the others in 1907. Note the early wagon.

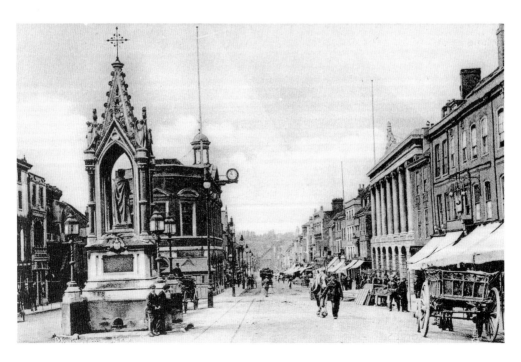

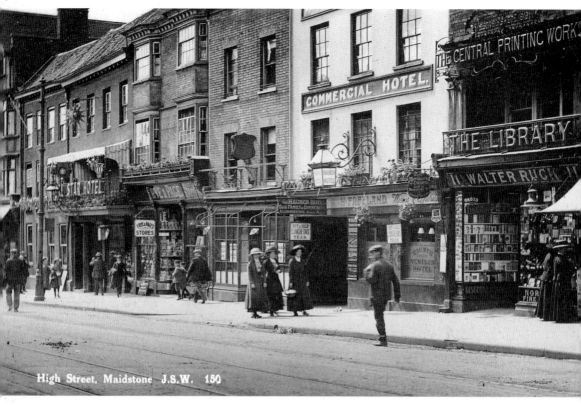

High Street, Maidstone J.S.W. 150

THE MIDDLE HIGH STREET in 1912 showing the Royal Star Hotel, Frye & Page's grocery store, the Haunch of Venison hotel and Walter Ruck's stationers and printing works. The Haunch of Venison, which advertised good stables and 'the most central house for cyclists', became redundant in 1918 and was sold to the London Guarantee & Accident Co. Ltd. for £2,700.

Left (bottom): THIS 1904 VIEW OF THE TOP OF THE HIGH STREET shows Queen's Monument, the town hall and, on the right, the Kent Fire Office. Queen's Monument was presented to the town in 1862 by Alexander Randall, High Sheriff of Kent. The Town Hall, built in 1763, incorporates the clock, cupola and market bell from the original water conduit which stood near the Royal Star Hotel until 1793.

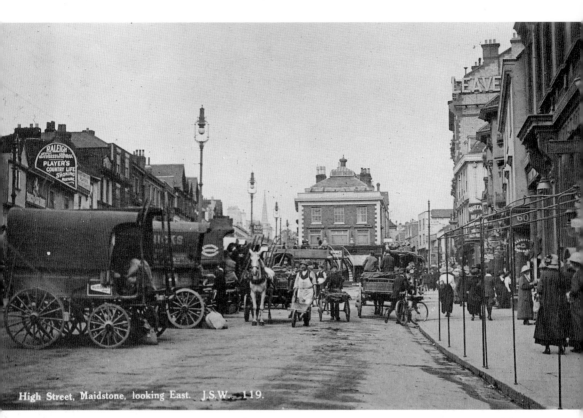

High Street, Maidstone, looking East. J.S.W. 119.

A BUSY TRANSPORT SCENE is depicted in this 1910 photograph of the lower High Street, with carriers' carts standing in the middle of the road. The carriers provided a reliable daily service to Maidstone, bringing people and all kinds of wares from the outlying villages. The horses were watered and fed at local stables before returning on their homeward journey. The iron frames on the pavement were supports for the shops' awnings.

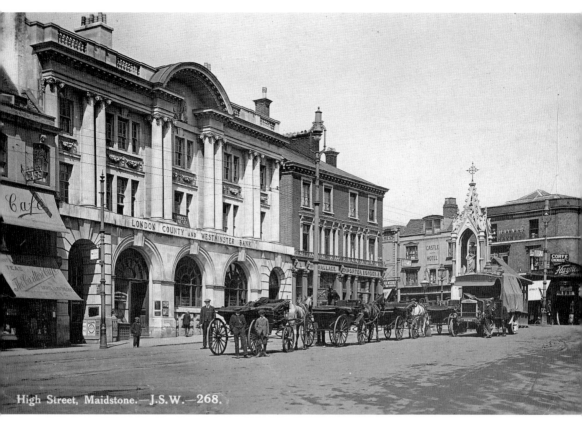

High Street, Maidstone.—J.S.W.—268.

A LINE OF CARRIAGES outside the new London County & Westminster Bank in the High Street in 1913. The offices above the bank are still 'To Let'. The horses were often 'borrowed' from the rank by Maidstone's Fire Brigade, stationed in Market Buildings. To the right of the bank is the Red Lion public house, known for many years as the Gin Palace as it had a small bar for ladies only. A Red Lion Inn had occupied this location on the corner of Week Street since 1650, when it belonged to John Saunders of the Lower Brewery in Stone Street. The public house was rebuilt in 1857. Burton Menswear now occupy these premises.

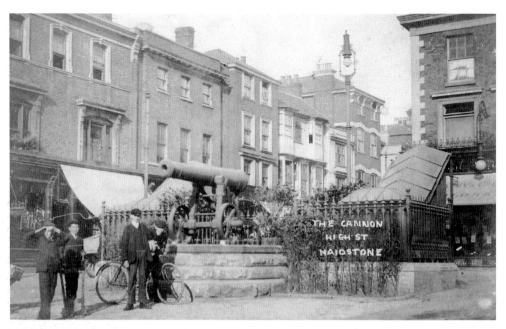

THIS HIGH STREET SCENE, photographed in 1905, shows the Russian Cannon that was captured during the Crimean War and presented to Maidstone by Lord Panmure in 1858. On either side are the entrances to the public conveniences that were erected in 1901.

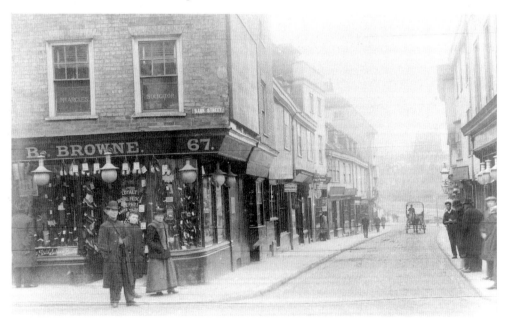

MILL STREET, looking south from the High Street, in 1900. All the buildings on the eastern side were demolished in 1907 when the road was widened to make way for the Loose tramway. In October 1940 many of the buildings on the western side were severely damaged in one of Maidstone's worst air raids.

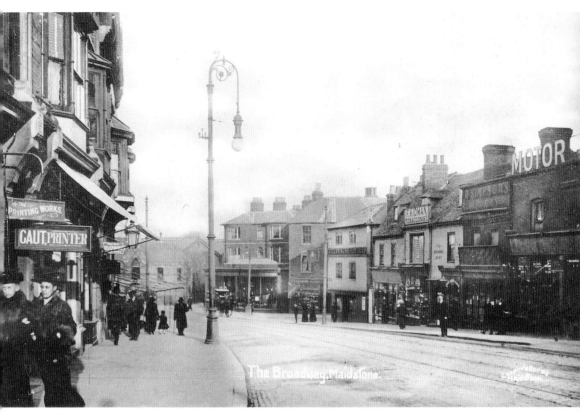

THE BROADWAY, LOOKING TOWARDS MAIDSTONE BRIDGE, in 1912. The ornate lamp standard also served as a support for the overhead wires of the tramway. Every building, except Drake & Fletcher's Motor Works (now Waldron's Car Showrooms) has since been demolished and a modern shopping centre has taken the place of the shops on the left hand side.

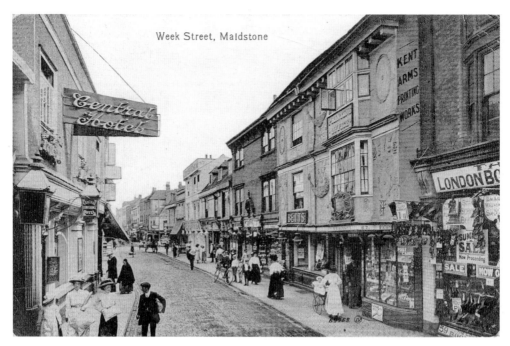

Week Street, Maidstone

WEEK STREET, Maidstone's main shopping street, in 1910. The pargetting on the front of Betts' butchers shop may still be seen although the premises are now occupied by Boots the chemists.

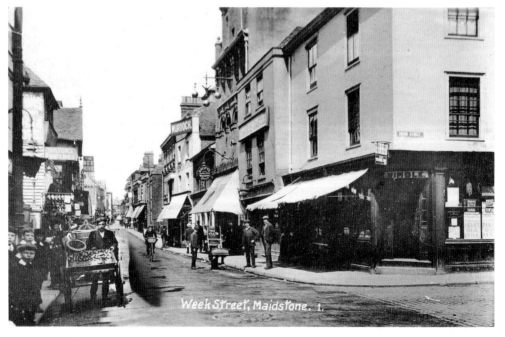

Week Street, Maidstone. 1.

THE UNION STREET CORNER OF WEEK STREET in 1909. Wimble's, Week Street Post Office, occupied the corner shop; Crofts, the pawnbrokers, were further along and the original Beehive Stores and Hiltons Booteries were on the opposite side of the road.

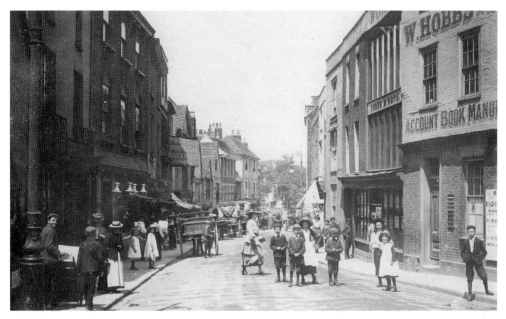

LOWER STONE STREET in 1903. Note the children's interest in the camera and the tree-lined street towards Gabriel's Hill. William Hobbs' wholesale stationery warehouse was on the right and the Fisherman's Arms (still there today) can be seen further down on the left.

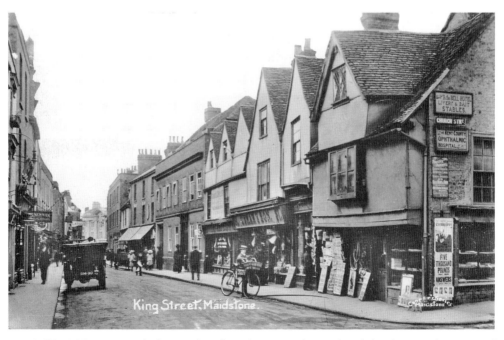

KING STREET in 1914. Clarkes modern furnishing store has replaced the shops at the corner of Church Street and most of the left side is engulfed in the new Chequers Shopping Centre.

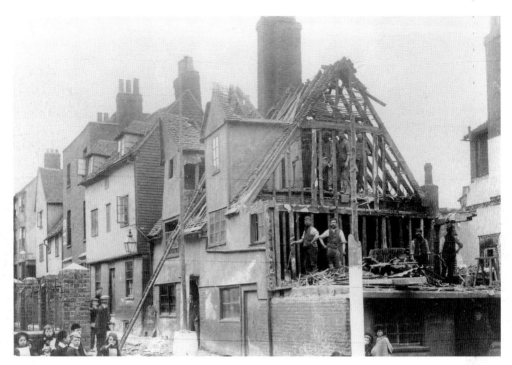

OLD HOUSES ON THE NORTH-WEST CORNER OF PUDDING LANE, undergoing demolition in 1897.

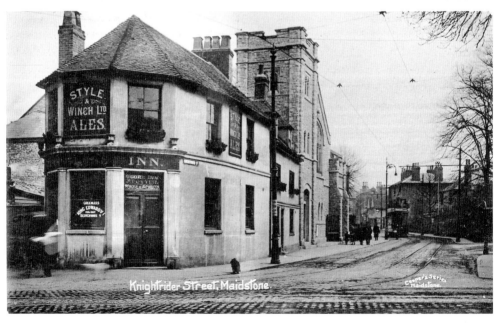

KNIGHTRIDER STREET in 1909. The gabled building behind the tram (the Forester's Arms) was destroyed by a delayed action bomb in 1940. The Globe Inn was demolished in the 1960s to make way for an extension to the Baptist Church and widening of the road.

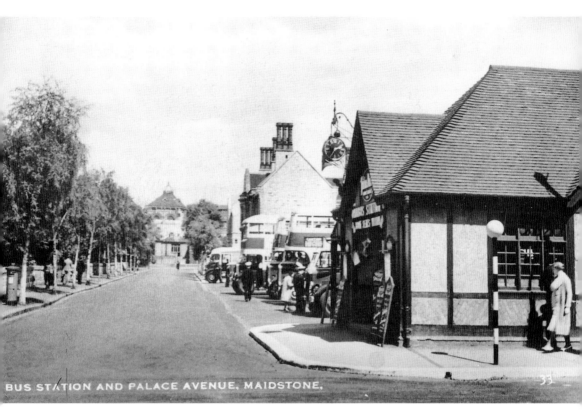

PALACE AVENUE in 1937. The bus station, which was the first in the country, was opened in 1922 and closed in 1976. The booking office on the right was subsequently re-erected at Tenterden Station on the Kent & East Sussex Railway, where it houses the restaurant. At the far end of Palace Avenue may be seen the Lower Brewery building, which was demolished in the early 1970s; the decorative wrought ironwork on top was salvaged and erected over the wishing well at the entrance to Brenchley Gardens.

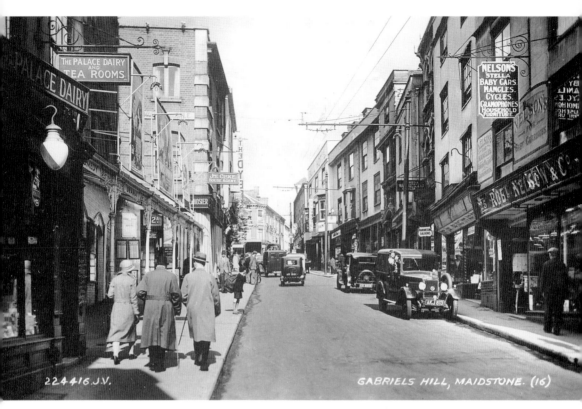

GABRIEL'S HILL in 1938, showing the Palace Theatre on the left. Note the single set of trolleybus wires on the outward route to Loose. Trolleybuses entered the town on the return journey via Mill Street. A two-way system was constructed on Gabriel's Hill in 1940 when Mill Street was rendered impassable through bombing.

SECTION FOUR

Shops

Towards the end of the nineteenth century, High Street, Week Street and King Street were lined with small, independently run shops of all descriptions, while nearly every street corner boasted a small general shop that sold practically everything.

Shops often started in the front parlour of a house while the occupants lived in the back room and upstairs. Many of these small shops prospered and expanded into larger premises.

Shop assistants worked long hours, often not finishing until 10 p.m.; conditions did improve in 1912 when half-day closing came into operation.

In Maidstone there was a variety of shops, including several bakers, butchers, dairies, grocers, drapers, ironmongers and boot shops. There were at least two bazaars in the town: the Penny Bazaar (the forerunner of the Marks and Spencer Store) in Week Street and the Sixpenny Bazaar in the High Street.

Even in today's age of the superstore some of the small shops have remained. Cliffords, who were rope and twine manufacturers in the eighteenth century, have been trading continuously as a family business in Bank Street since 1800, while Stonham's the chemist and the Golden Boot shoe retailer have traded in Maidstone for more than 200 years.

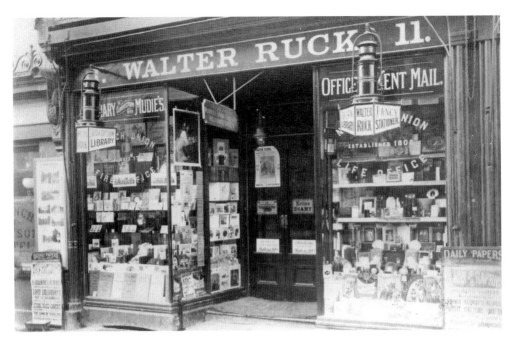

WALTER RUCK'S STATIONERY SHOP AND SUBSCRIPTION LIBRARY at 11 High Street was established in 1808. The business passed to W.H. Smith & Son in 1926. The premises are now occupied by Quality Seconds Ltd., clothing retailers.

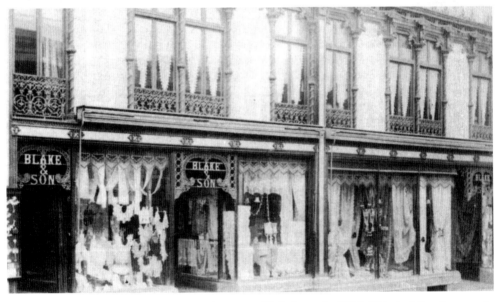

BLAKE & SON'S DRAPERS SHOP in the upper High Street in 1906. This building is an early example of cast-iron frame construction with tiled infilling, designed by Ashpitel & Whichcord in 1855. Blake & Son's shop had an automatic overhead cash railway until its closure in the 1970s. The building has since been refurbished and is now occupied by the Royal Bank of Scotland Ltd. and Thomas Cook's travel agency.

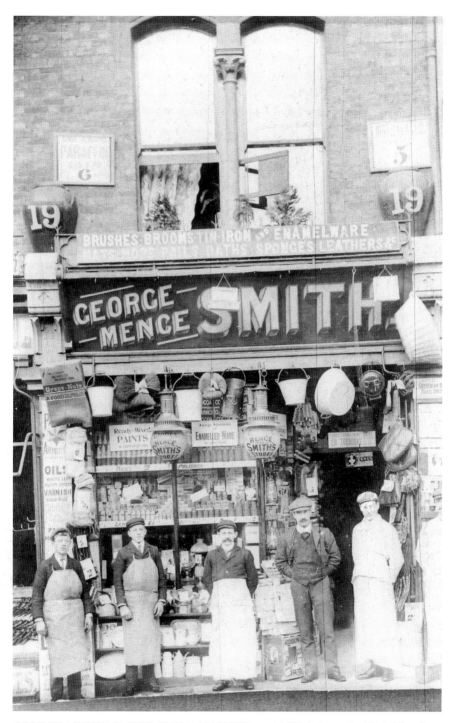

GEORGE MENCE SMITH, IRONMONGERS, at 19 High Street in 1910. The shop was advertised as 'the best and cheapest market for paints, oils, colours, varnishes, stains, enamels, paper hangings and all household requisites'.

33

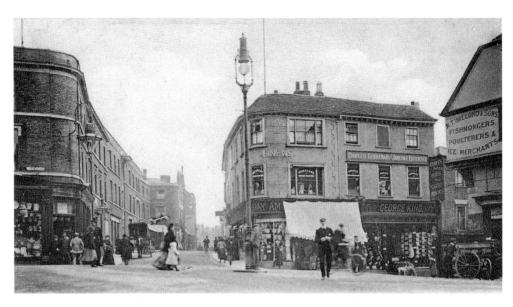

KING STREET photographed from the Queen's Monument in 1904. Haynes ironmongers shop (now demolished) was on the Week Street corner and John Day Ambrose & Son, drapers, always affectionately known as 'Ambroses', occupied the opposite corner.

THE ORIGINAL BEEHIVE STORES in 1908. This shop, belonging to John Charles Tye, was situated in front of the Congregational Chapel in Week Street. In 1925 the business moved to 68, 70 and 72 Week Street, where C. & H. Fabrics is today.

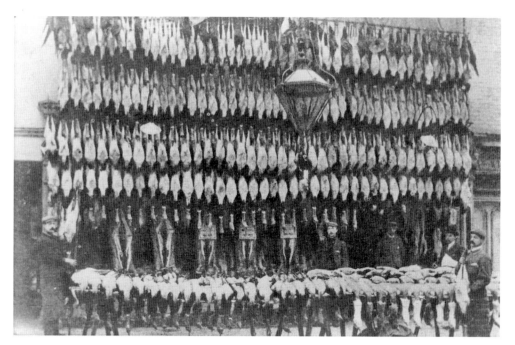

THIS SPLENDID CHRISTMAS DISPLAY OF POULTRY was photographed outside Clement & Sharp's butchers shop in the High Street in December 1909.

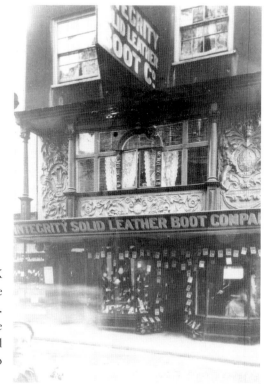

THE PARGETTED SHOP, 78 BANK STREET, when it was occupied by the Integrity Leather Boot Company in 1901. Originally the whole of the front of the building was adorned with ornamental pargetting; the decoration on the upper two stories was removed *c*. 1820.

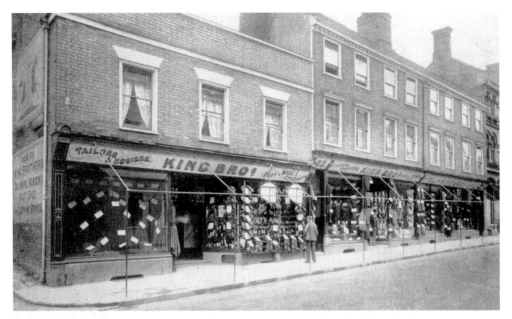

KING BROS. TAILORS AND CLOTHIERS at 21, 23 and 25 Lower Stone Street in 1920. Osborn House stands on the site today. This postcard was one of a pack of five, given to a customer at King Bros. in lieu of a farthing change.

ALFRED CHANTLER STANDS AT THE DOORWAY of his new general shop and off-licence at 40 Waterloo Road in 1882. These houses had just been built by Sir Sidney H. Waterlow Bt., MP. The shop closed shortly after the Second World War.

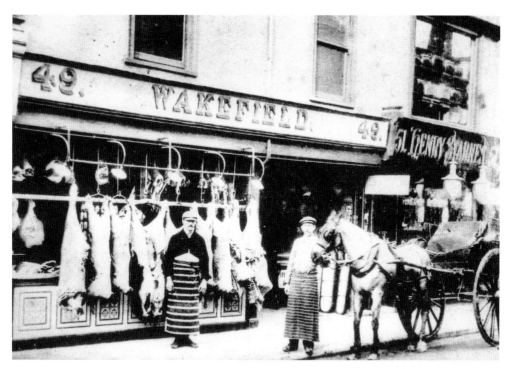

EDWARD WAKEFIELD AND HIS ASSISTANT outside his butchers shop at 49 Week Street in 1909.

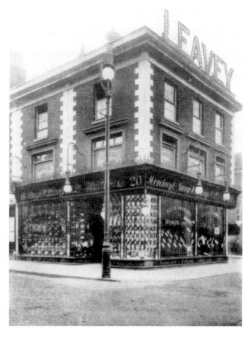

GEORGE LEAVEY'S OUTFITTERS SHOP at the western end of Middle Row in 1900. The large electric sign lit up one letter at a time until the whole word 'LEAVEY' was illuminated. In 1910 the business moved to the north-west corner of Mill Street and finally closed in 1988.

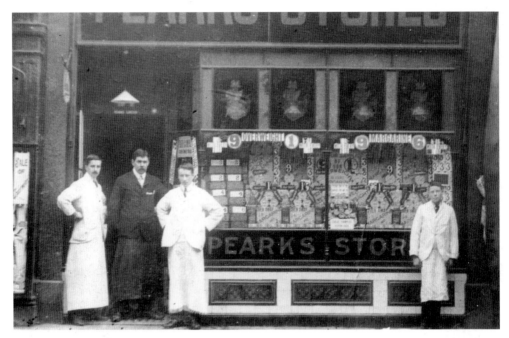

THE MAIDSTONE BRANCH OF PEARKS GROCERY STORES at 37a Week Street in 1927. By the 1930s the firm had moved to 9 Earl Street.

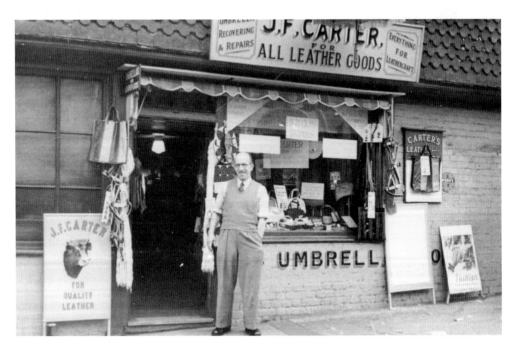

'THE UMBRELLA MAN', JAMES CARTER, outside his shop at 21 Upper Stone Street shortly after the Second World War. The premises later became 'The Model Shop', still managed by the Carter family. The business closed in the 1980s.

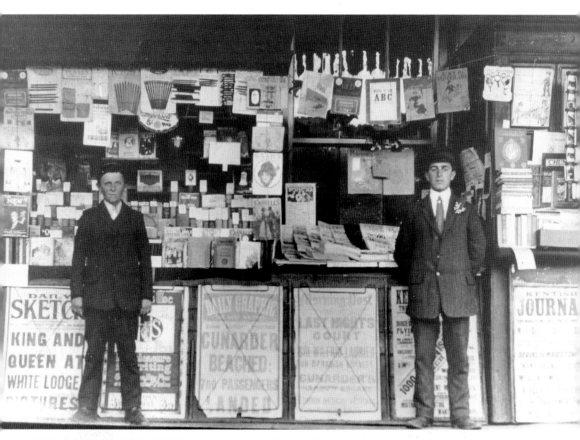

THE NEWSAGENTS STAND on Maidstone East railway station in 1911. Note the posters advertising former national newspapers and the local paper, the *Kentish Journal*, that ceased publication in 1912.

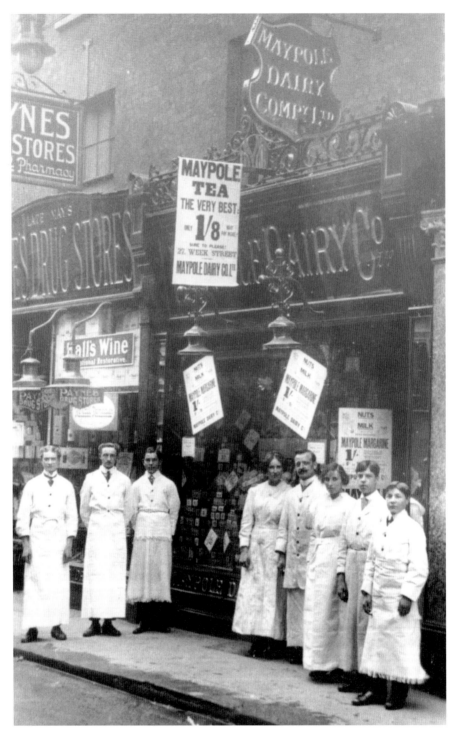

THE STAFF OF THE MAYPOLE DAIRY CO. line up outside their shop at 27 Week Street in 1916.

SECTION FIVE

Inns and Taverns

Maidstone, situated at the centre of the hop and barley-growing region of Kent, was well endowed with breweries and so had more beerhouses than many other similar sized towns.

In the mid-Victorian era, when beer drinking and drunkenness were at their height, there were more than fifty drinking houses between the Flower Pot in Sandling Road and the Fortune of War at the top of Upper Stone Street, a distance of about one and a quarter miles.

By 1904 beer consumption had declined and an act was passed whereby public houses could be closed on social grounds where they were considered to be superfluous. Between 1904 and 1918 there were about forty redundancies in Maidstone. Names like the Elephant and Castle, the Three Tuns, the Haunch of Venison, the Marquis of Granby and the Duke of Wellington were no more.

The years between the wars never saw the return of the excessive drinking habits of the previous generation and drunkenness became the exception rather than the rule. The trade had to wait until the Second World War before beer consumption began to rise again.

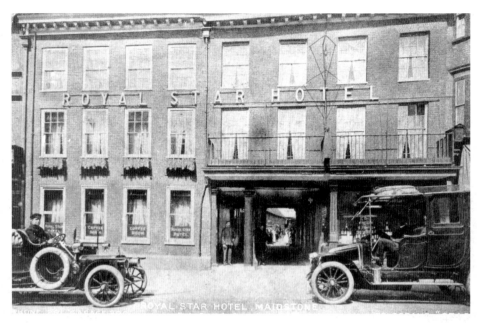

THE ROYAL STAR HOTEL in 1916. This inn dated back to the sixteenth century and was Maidstone's leading hostelry. Among its guests were Princess Victoria (later to become Queen), who visited the inn with her mother the Duchess of Kent, and Benjamin Disraeli when he was MP for Maidstone in 1837. The inn and grounds were converted into the Royal Star Shopping Arcade in 1986.

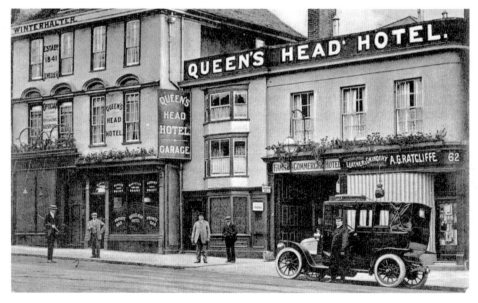

THE QUEEN'S HEAD HOTEL, 63 High Street, in 1915. This hotel was one of the principal coaching inns in Maidstone in the eighteenth and nineteenth centuries. Until the late 1920s carriers stabled their horses in the yard at the rear of the hotel.

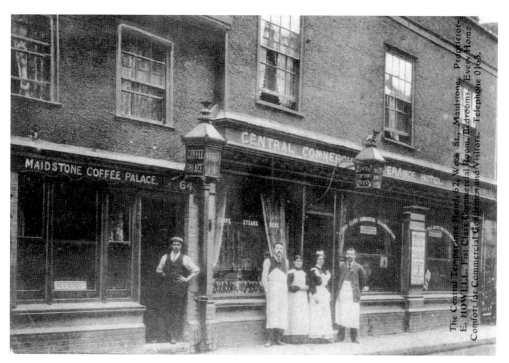

THE CENTRAL TEMPERANCE HOTEL AND COFFEE PALACE IN WEEK STREET. Edward Howell (on the far right) and his staff are pictured outside in 1904. Littlewoods store is now on this site. There were two temperance hotels in Maidstone, the other being Winterbottom's in Gabriel's Hill.

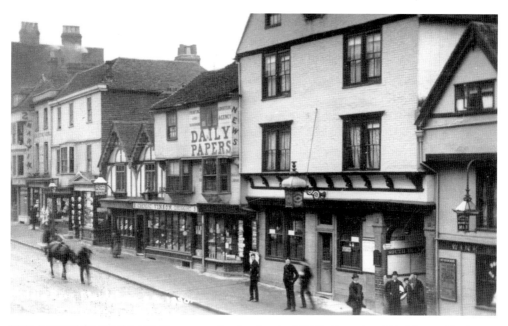

THE MARQUIS OF GRANBY, next to the Sun Inn in Middle Row in 1890. This public house became redundant in 1904.

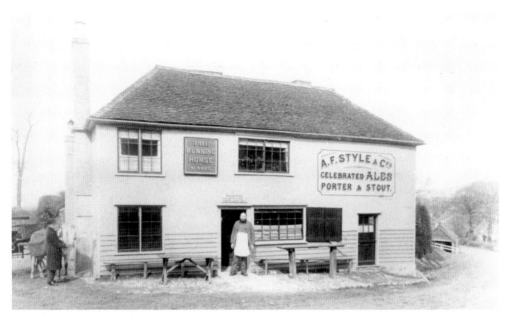

WILLIAM WARD IN FRONT OF THE OLD RUNNING HORSE PUBLIC HOUSE in the Chatham Road in 1890. A new public house, in mock Tudor style with a Norfolk reed thatch, was built on the site in 1938. The building was refurbished in 1987 and is now a Harvester Steak House.

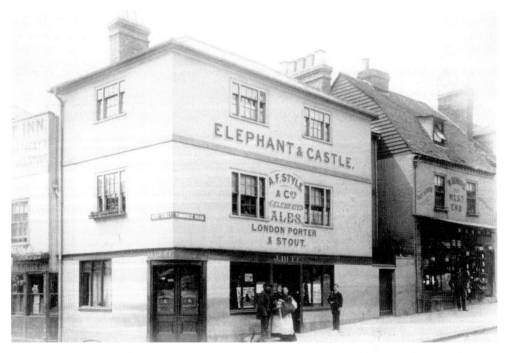

THE ELEPHANT AND CASTLE IN THE BROADWAY in 1890. This public house fell victim to closure in 1917. The building was used as a fish and chip shop for many years prior to its demolition in 1989.

SECTION SIX

A Working Life

For centuries Maidstone has been a centre of industrial and commercial activity. Many industries have flourished in the town, and provided a livelihood for many of the population, then declined and disappeared.

One of the older industries, ragstone quarrying, still flourishes and is carried out on a large scale around Maidstone. It was while quarrying in the Queen's Road area in 1834 that the fossilised remains of an iguanodon were found. The remains are now in the Natural History Museum at South Kensington. In 1949 the iguanodon was incorporated in the Maidstone arms.

Paper-making has remained an important trade and the firm of J. Barcham Green of Hayle Mill is still run by descendants of John Green who occupied the mill in 1810.

Other major local places of employment have been breweries, motor works, engineering works, nurseries and confectionery and food factories.

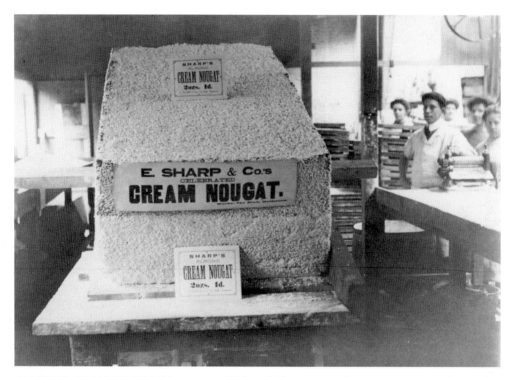

ALMOND CREAM NOUGAT was one of Edward Sharp's specialities in 1910, manufactured at his sweet factory in the former Roller Skating Rink in Sandling Road. In 1912 Edward purchased the old Invicta Works in St Peter's Street from Jesse Ellis and built his 'Kreemy Toffee Works' on the site.

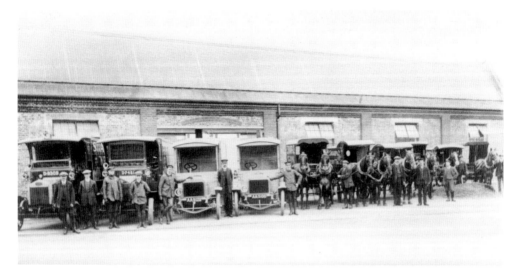

EDWARD SHARP'S FLEET OF VEHICLES lined up in 1913 outside the stables and garages at 57 St Peter's Street. The fleet consisted of two Hallford 4 ton motor vans, two smaller vans and six horse-drawn carts.

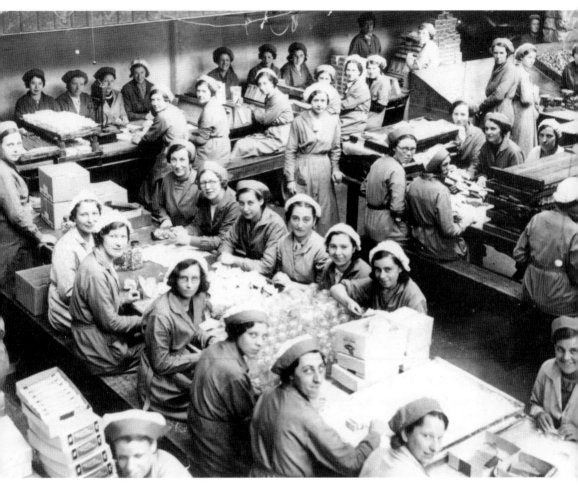

THE CONFECTIONERY ROOM AT SHARP'S KREEMY WORKS, St Peter's Street, *c.* 1930. In 1961 Sharp's merged with Robertson & Woodcock Ltd., who manufactured Trebor sweets, and the company became known as Trebor Sharps Ltd. The company continued to produce many of Sharp's more popular lines, including toffees, extra strong mints and, until quite recently, Easter eggs.

GEORGE FOSTER CLARK (1864–1932), founder of the Eiffel Tower Food Manufactory (Foster Clark Ltd.) in Hart Street. Throughout the First World War he was not only chairman of his company but also Mayor of Maidstone in 1916, 1917 and 1918. Between 1917 and 1925 he held the position of Hop Controller for the country.

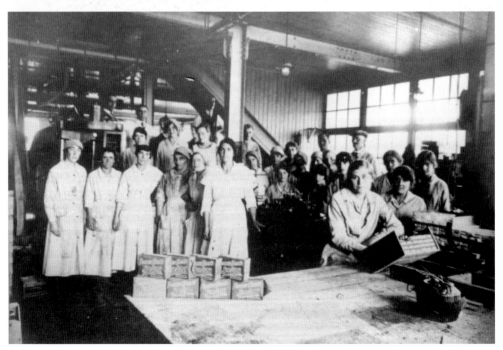

AN INTERIOR VIEW OF FOSTER CLARK'S FACTORY in Hart Street, *c.* 1918. The firm was famous for its custard powder, blancmange powder, jellies, soup and lemonade products. The Foster Clark name was sold to Oxo Ltd. in July 1965 and the factory closed.

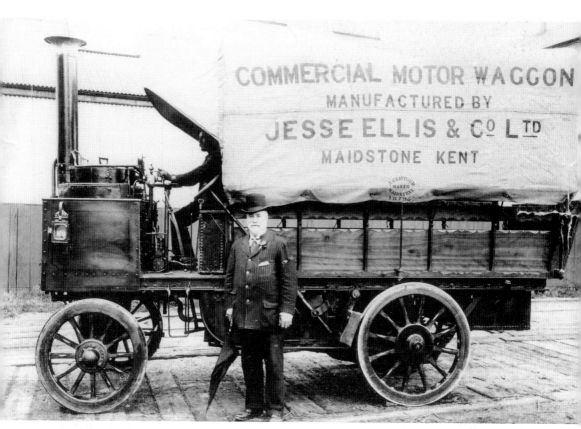

JESSE ELLIS STANDING BY ONE OF HIS STEAM WAGONS at Invicta Works, St Peter's Street in 1903. Note that the wagon's canvas tilt was manufactured by James Clifford of Maidstone. Jesse Ellis, originally a traction-engine operator, started his business in Maidstone *c.* 1870, when he was a road haulage and maintenance contractor. In 1895 he carried out the contract for remaking the Thames Embankment roadway. He later developed his own steam lorries and in 1902 personally introduced the steam wagon into Egypt. In 1904 Jesse Ellis exhibited his steam wagons at the Royal Agricultural Show and in the same year ran a steam bus from Maidstone to Loose. His steam vehicles were not, however, a financial success and the company ceased trading in 1912.

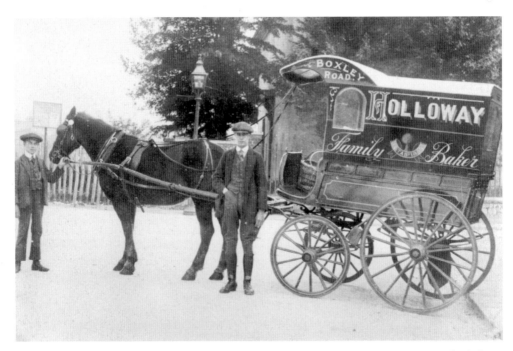

HOLLOWAY'S BAKERS CART in front of the allotments in Albert Street in 1910. The bakery, established in 1834, was for many years at 69 Boxley Road and later at 28 Brewer Street. A sign on the side of their shop read 'Often buttered - never bettered!'

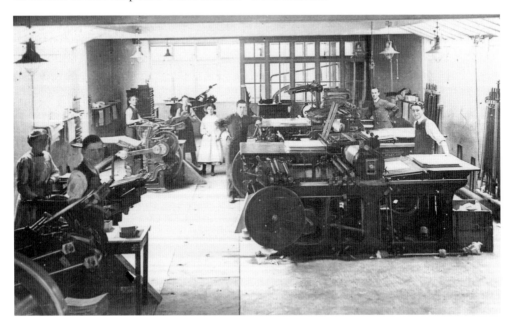

AN INTERIOR VIEW OF YOUNG & COOPER'S PRINTING WORKS at 72 Bank Street in 1914. At that time the firm was one of the main publishers of postcards in Maidstone. About thirty-five years ago Young & Cooper's moved to 30 High Street.

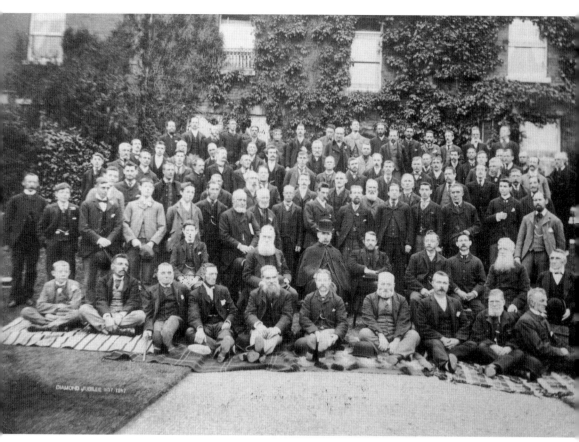

RALPH FREMLIN THE BREWER (in bowler and cape) with his three brothers and his employees in his garden at Heathfield House on the occasion of Queen Victoria's Diamond Jubilee in 1897. Ralph Fremlin founded his brewing business in an almost derelict brewery in Earl Street in 1861. With the help of his brothers the business prospered and in 1871 a new brewery was built. Fremlins merged with Whitbread & Co. in 1967.

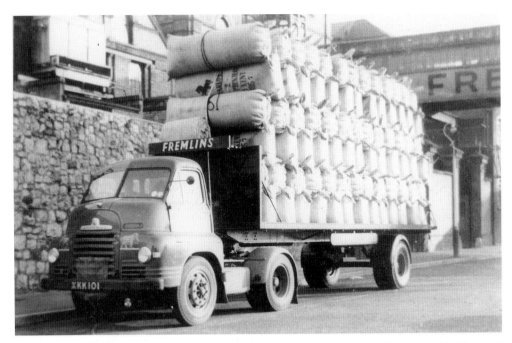

A LOAD OF HOPS ARRIVING AT FREMLINS' BREWERY *c.* 1950. The covered bridge and connecting riverside building were demolished when the new road system and St Peter's Bridge were built in 1978. Fremlins' Victorian brewery, which can be seen in the background, was pulled down in November 1981 and a new distribution unit and headquarters for Whitbread Fremlin Ltd. erected on the site.

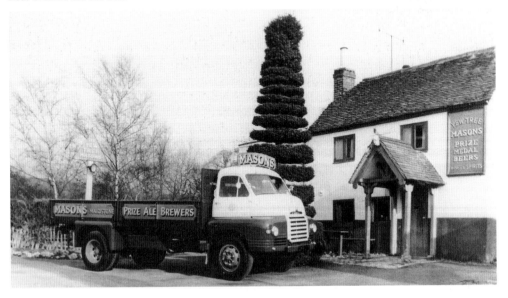

MASON'S DELIVERY DAY at the Yew Tree Inn, Sandling, *c.* 1950. Edward Mason's brewery, established at Waterside, Maidstone, *c.* 1820, was taken over by Shepherd Neame Ltd. in 1956 and later demolished.

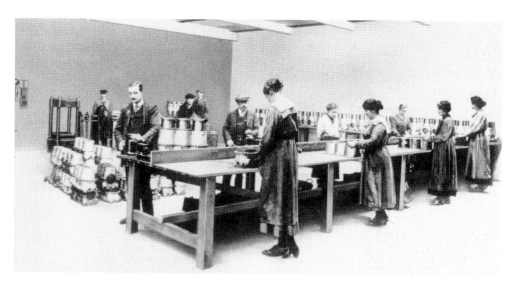

INSIDE THE LEN ENGINEERING WORKS (Rootes Ltd.), Mill Street, in 1917. This photograph shows both male and female workers making their contribution to the war effort by repairing aero engines for the government.

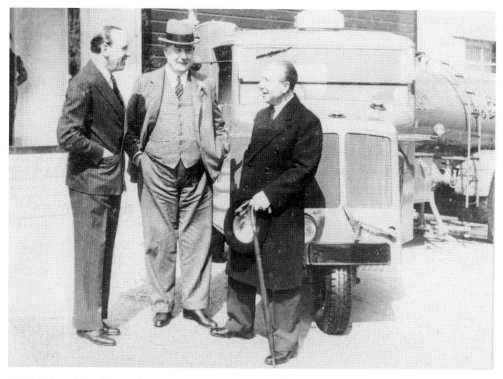

THIS PHOTOGRAPH, taken in 1938 after the opening of Rootes' new showrooms in Mill Street, shows, from left to right: William Rootes (who later became Lord Rootes of Ramsbury), the Mayor of Maidstone, Councillor W.R. Hyde and Alfred C. Bossom, MP for Maidstone. In the background is a Karrier A.R.P. trailer unit.

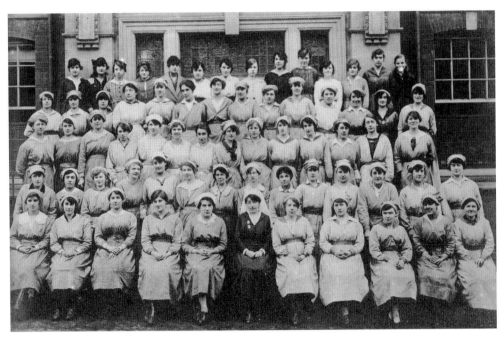

WOMEN WAR WORKERS photographed on their last day at Tilling-Stevens Ltd.'s Victoria Works in St Peter's Street at the end of the First World War. They were all discharged when demobilized men returned to work.

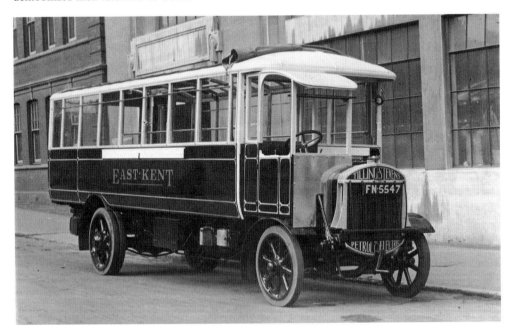

A TILLING-STEVENS PETROL-ELECTRIC BUS outside the factory in 1924. The firm was purchased by Rootes in September 1950, who, in turn, were taken over by Chrysler in 1967 and then by P.SA., the French car giant controlling both Peugeot and Citroen.

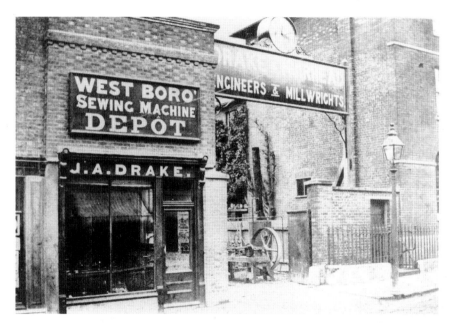

THE BROADWAY PREMISES of the engineering firm of Drake & Muirhead, *c.* 1880. The company was founded in Sandling Road in 1874 and moved to the Broadway in 1876. The name of the firm was changed to Drake & Fletcher Ltd. in 1898.

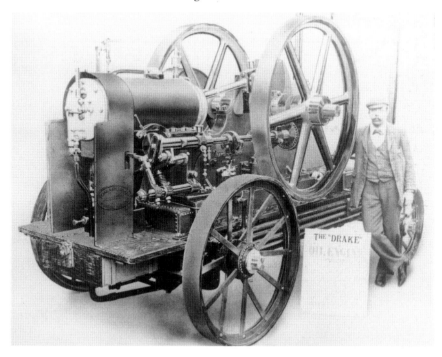

JAMES DRAKE standing by the oil and gas engine that he invented in 1885. The machine was suitable for farm and estate work, hop and fruit tree spraying, hop-drying, pumping and electric lighting. Many of these machines were still in use sixty years later.

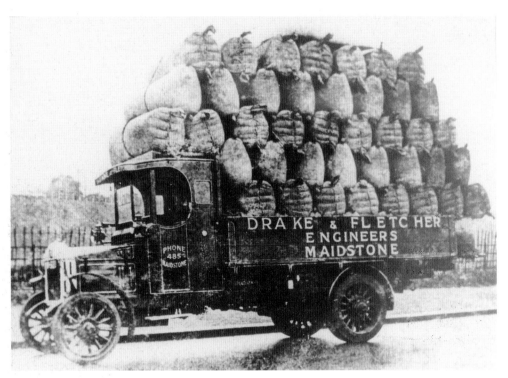

DRAKE & FLETCHER entered the motor and road haulage business in the early 1900s. This photograph shows one of Drake & Fletcher's road haulage vehicles in 1919.

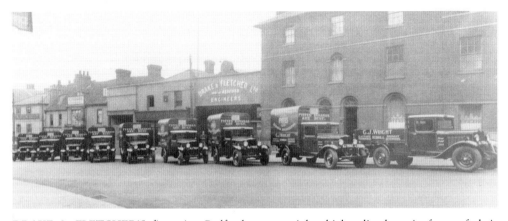

DRAKE & FLETCHER'S first nine Bedford commercial vehicles, lined up in front of their premises in the Broadway in June 1932. They were sold to G.J. Wright of Redhill for a total cost of £2,420 5s. 6d.

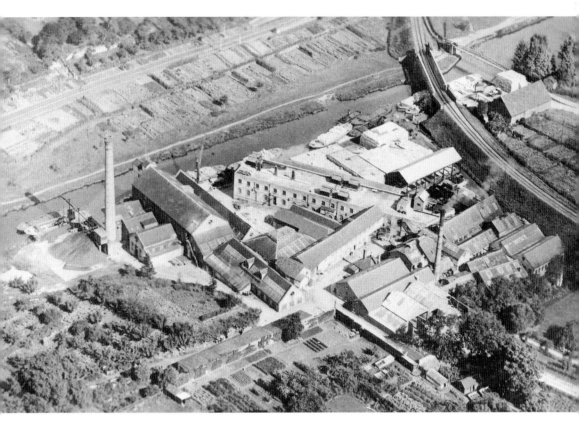

AN AERIAL VIEW OF BRIDGE PAPER MILL, TOVIL, *c.* 1930. This mill was one of thirteen watermills once worked along the Loose Stream between Woodlawn Park, Loose and where the stream meets the Medway at Tovil, a distance of about two miles. Bridge Mill, which originally belonged to the College of All Saints', was a fulling mill from about 1550 until 1700, when it was replaced by a gunpowder mill. A serious explosion occurred there in July 1731, when two men and a child were killed. By the early 1750s the mill had been converted for the production of linseed oil. In 1899 the mill was bought by Albert E. Reed, a paper manufacturer, who became one of the town's largest employers. The mill closed for economic reasons in July 1983.

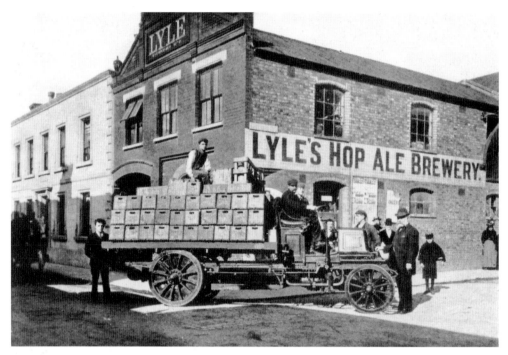

DANIEL T.J. LYLE stands in front of his first motorized van, outside his works at East Layne House, King Street, in 1901. The company ceased trading in 1966.

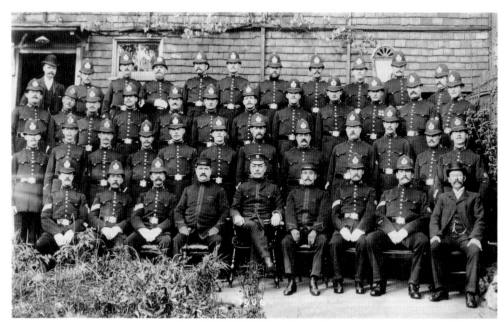

MAIDSTONE BOROUGH POLICE FORCE pose for the photographer outside King Street Police Station in 1906. A.C. Mackintosh, the first Chief Constable (from 1895 to 1921), is in the middle of the front row. The Borough Police Force merged with the County Police in 1943.

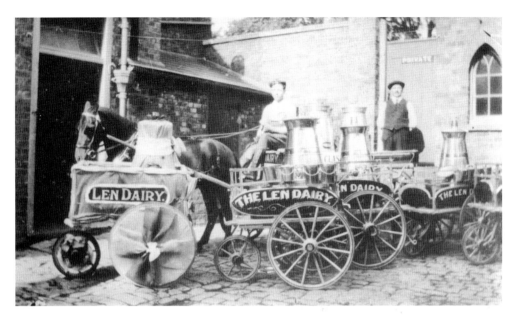

WALTER WICKENS, THE PROPRIETOR OF THE LEN DAIRY, standing in his yard at Romney House about 1910. In the mid-1920s Wickens bought out Jordon & Pawley's Primrose Dairy at 32 King Street and in the ensuing years the Primrose & Len Milk Bar (now demolished) was opened on the corner of Romney Place and Lower Stone Street. Other small dairies were taken over, firstly by Walter Wickens, and, after his death, by his son Jack. Romney House remained the main office of Primrose & Len Dairies Ltd. until 1979, when the firm was taken over by the Express Dairy Co.

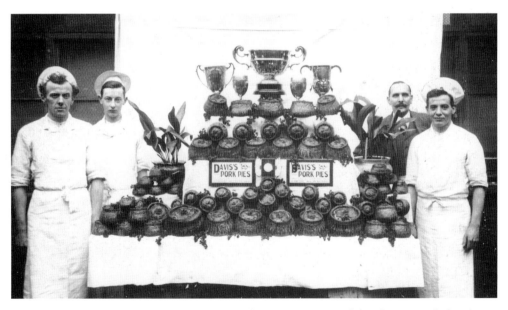

HENRY DAVIS & SONS, BAKERS at 65 Week Street, were noted for their Kentish farmhouse bread and pork pies. In 1906 they won a gold medal and diploma for pork pies in the London Exhibition. By 1910 they had received forty cups and medals.

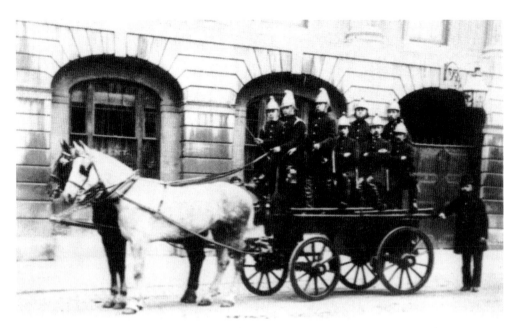

THE KENT FIRE OFFICE BRIGADE on their new 1883 Merryweather manual fire engine, in front of the Fire Office building in the High Street. In 1901 the Maidstone Borough Fire Brigade was established, taking over from the 'Kent' and the Volunteer Fire Brigade, which had been supported by the Corporation since 1873.

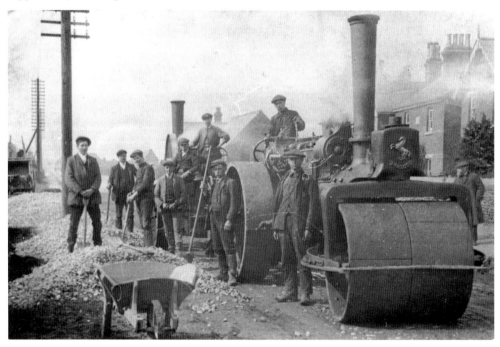

A LOCAL GANG MAINTAINING THE ROADS in 1907, using stone chippings and an Aveling & Porter steam roller, built in Rochester. Tarring the roads was not introduced until about 1910.

SECTION SEVEN

Education

Maidstone Grammar School was founded by the Corportion in 1549 at Corpus Christi Hall in Earl Street. It was the replacement for an older school which had been in existence since 1348. The grammar school moved to larger premises in Tonbridge Road in 1871 and to its present building in Barton Road in 1930. The Maidstone Grammar School for Girls was opened in Albion Place in 1888, transferring to Great Buckland in 1938.

Apart from the grammar schools, another small educational establishment existed in Maidstone for nearly two centuries. This was the Bluecoat School, founded in the High Street in 1711 and for many years located in the old workhouse in Knightrider Street. The premises were vacated around 1900 and the children sent to the two grammar schools.

During the period covered by these photographs Maidstone had a number of church and council schools for primary and secondary education and several private schools.

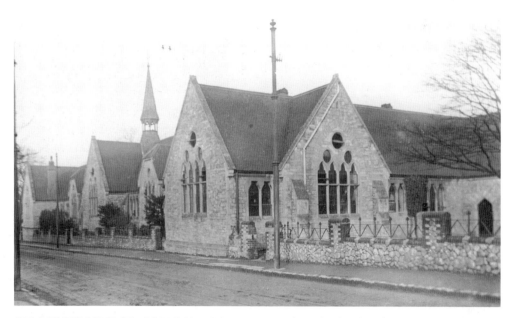

ALL SAINTS' SCHOOL, COLLEGE ROAD, in 1912. This school is the oldest Church of England primary school in Maidstone. It was created in 1814 from a smaller school which had been started in 1787. The school looks much the same today except for the loss of its bell tower.

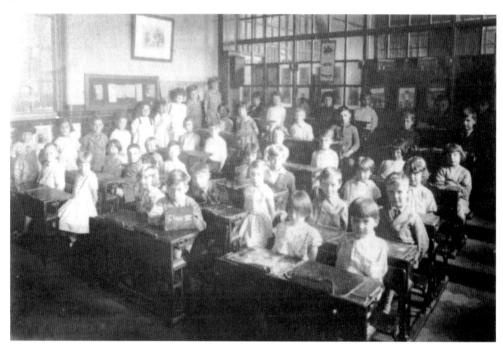

CLASS VII, EASTBOROUGH SCHOOL, UNION STREET, in 1932. The headmistress was Miss Sarah Hurley. Stuart Murray, the owner of this photograph, can be seen bending forward in the second row.

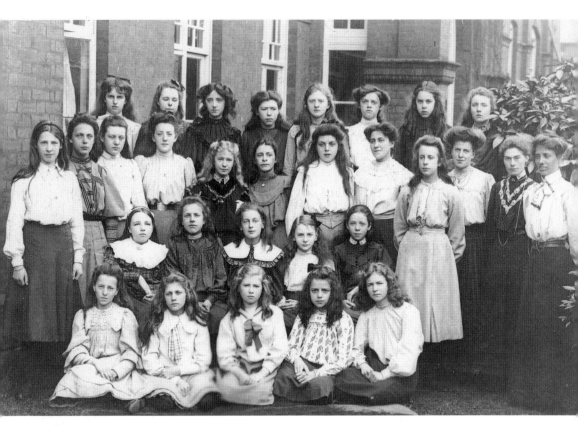

GIRLS AND STAFF in front of the Maidstone Grammar School for Girls, Albion Place, Sittingbourne Road, *c.* 1914. After the grammar school moved to Buckland Road in 1938 this building was used to accommodate sixth form pupils from Maidstone Technical School for Girls. The building was demolished in 1989.

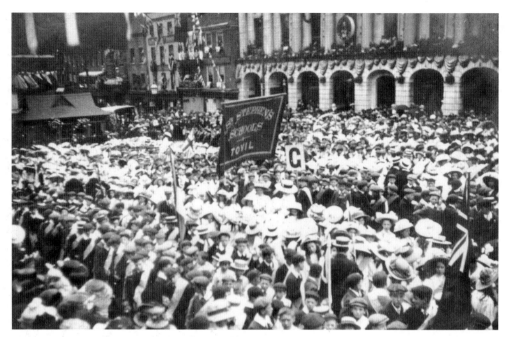

MAIDSTONE'S SCHOOLCHILDREN assembled in the High Street on Friday 23 June 1911 to celebrate the Coronation of King George V. Afterwards they attended a fête in Mote Park. The large banner was carried by the children from St Stephen's School at Tovil.

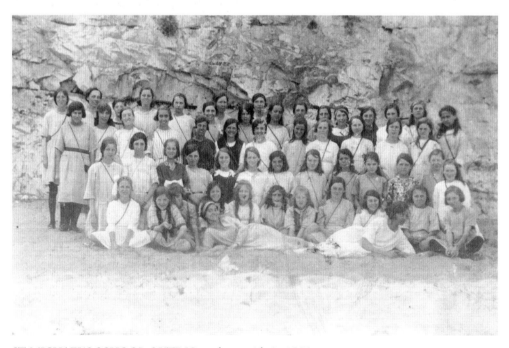

ST MICHAEL'S SCHOOL OUTING to the seaside in 1923.

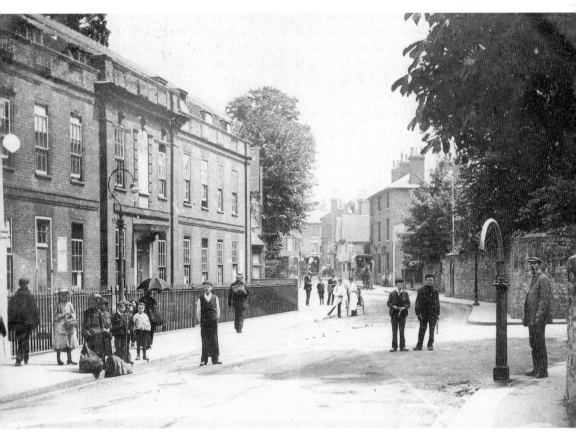

THE OLD BLUECOAT SCHOOL IN KNIGHTRIDER STREET, *c.* 1900. Maintenance of the school was largely by legacies and subscriptions and the children were selected each May at a general meeting of subscribers. Portraits of a boy and a girl scholar dressed in the distinctive blue school uniform may be seen in Maidstone Museum. The building was partly demolished in 1907 to provide a site for the Baptist Church, and the clearance completed in the 1960s to make way for an extension to the church and a car park.

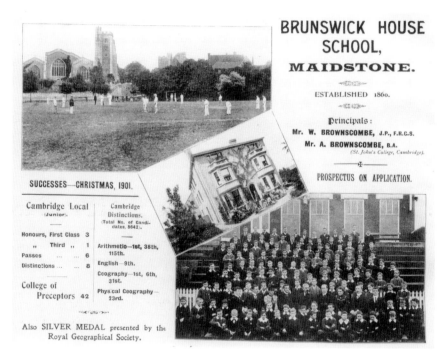

AN ADVERTISEMENT FOR BRUNSWICK HOUSE SCHOOL, BUCKLAND HILL, in 1902. This school, now a primary school, was for many years the Junior Department of the Maidstone Grammar School for Boys.

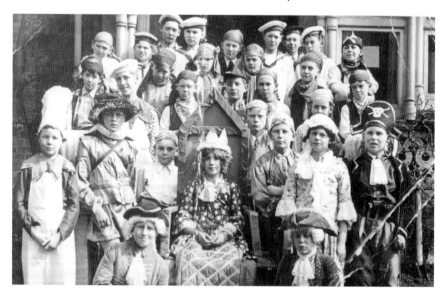

THE SCHOOL PLAY, PIRATES OF PENZANCE, performed at the Commercial School, The Elms, in London Road in 1938. Among those in the photograph are Colin Pantony, Ray Marshall, Jack Gibson, Colin Deitch, Richard Knight, Gerald Wilkinson, Stuart Murray, John Solly, John King, the Swan brothers and the Stearn brothers.

SECTION EIGHT

Health and Institutions

The first hospitals were maintained by religious bodies and were founded for a variety of charitable reasons. They housed the aged, provided education and cared for the suffering and needy.

In the nineteenth century purpose-built hospitals for the sick were built in all the larger cities and towns and were usually supported by voluntary contributions; some were general hospitals and infirmaries while others were devoted to specific diseases. The majority were absorbed into the National Health Service on its creation in 1948.

Three hospitals were established in Maidstone; these were the West Kent General Hospital in 1833, the Kent County Opthalmic and Aural Hospital in 1852, and the Maidstone Isolation Hospital in 1884. Larger institutions, for the care of paupers and the mentally ill and for the detention of prisoners, were also built in the Maidstone area.

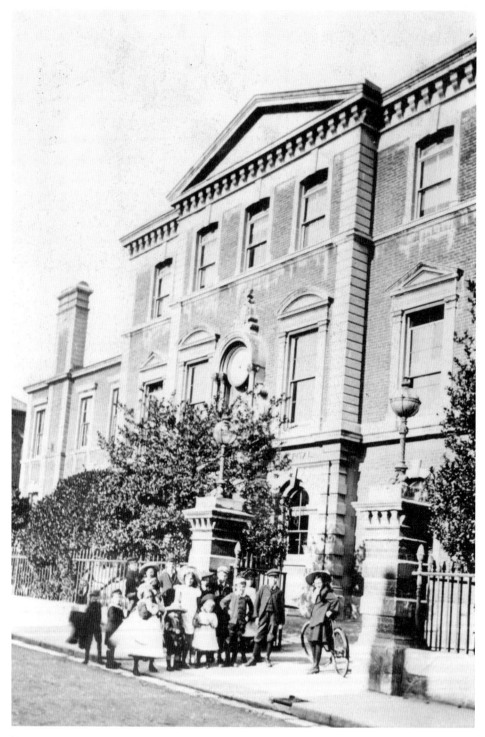

THE WEST KENT GENERAL HOSPITAL, MARSHAM STREET, in 1909. This hospital
served Maidstone for more than 150 years and was demolished in 1988.

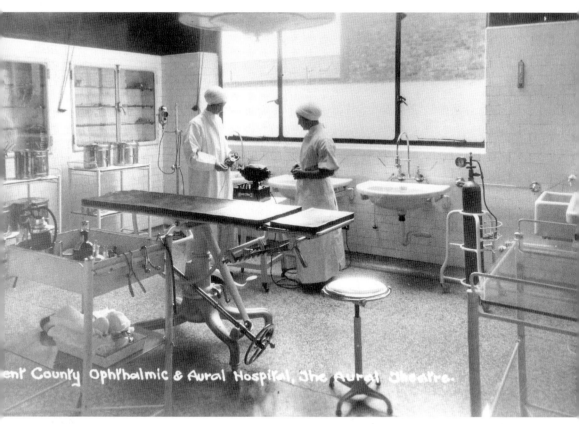

ent County Ophthalmic & Aural Hospital, The Aural Theatre.

THE AURAL THEATRE, Kent County Opthalmic and Aural Hospital, Church Street, in 1927. This hospital, one of the first in the country to use ether as an anaesthetic, was founded in 1846 in the former preparatory school in Church Street, with accommodation for six patients. On 5 October 1852 the present hospital was opened on the site at a cost of £3,000, of which £500 was raised by a penny subscription from the working classes throughout the county. Since then many additions and improvements have been made.

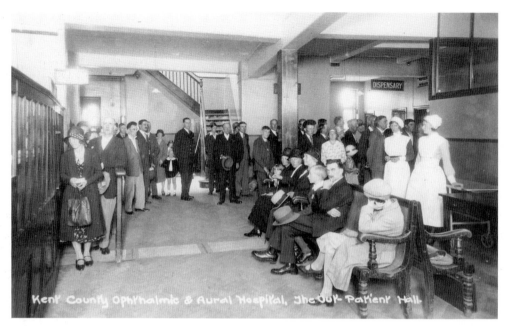

Kent County Ophthalmic & Aural Hospital, The Out-Patient Hall

THE OUTPATIENT HALL AND DISPENSARY at the Opthalmic and Aural Hospital photographed in 1927.

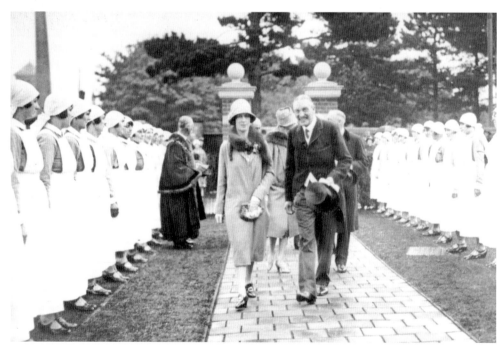

SIXTY NURSES FORMED THE GUARD OF HONOUR for Princess Mary, Viscountess Lascelles, when she opened the Nurses' Home for the Kent County Mental Hospital on 7 June 1927. The Princess was received by the Lord Lieutenant of Kent, the Marquis Camden.

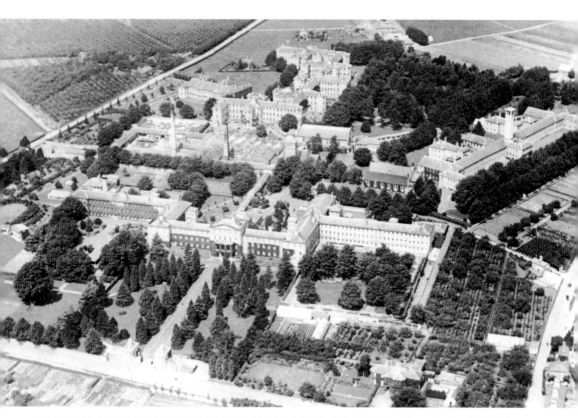

AN AERIAL VIEW OF THE KENT COUNTY MENTAL HOSPITAL at Barming in 1930. The hospital, opened on 1 January 1833 to accommodate 174 patients, was considered to be one of the most modern asylums of its kind. Designed by John Whichcord Sen., the building, like many other mental homes in the country, was modelled on prison lines. The main entrance, facing south, is in St Andrew's Road, formerly Asylum Road, and Hermitage Lane crosses the top left corner of the photograph. The new Maidstone General Hospital is now on the northern edge of the site.

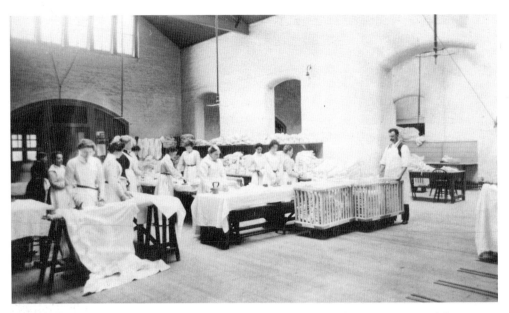

THE LAUNDRY ROOM AT BARMING ASYLUM, photographed in 1904. Many of the inmates helped with the ironing.

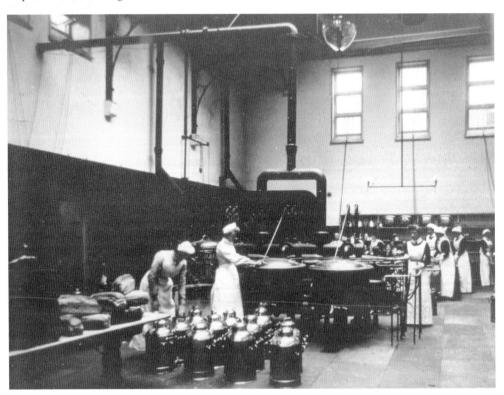

THE KITCHEN AT THE ASYLUM, also photographed in 1904. Here too help was provided by some of the patients.

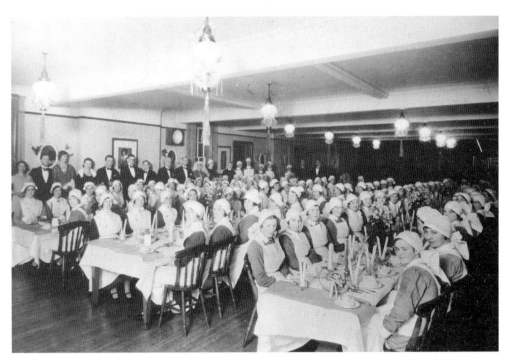

THE NURSES' DINNER AT THE MENTAL HOSPITAL in 1930.

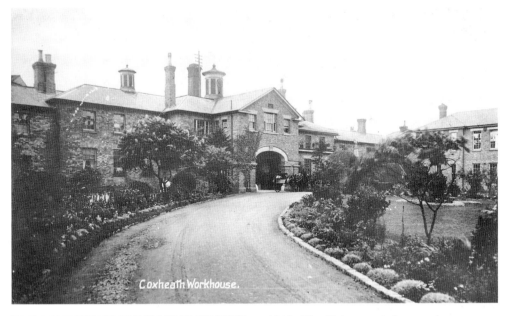

Coxheath Workhouse.

THE MAIDSTONE UNION WORKHOUSE, *c.* 1910. The Union, as it became known, was opened in March 1838 to take all the poor from Maidstone and the surrounding parishes. It was erected on the site of the former military camp at Coxheath and the old barrack square can still be seen in the grounds. The institution was later absorbed into the National Health Service and became Linton Hospital, caring mainly for the elderly.

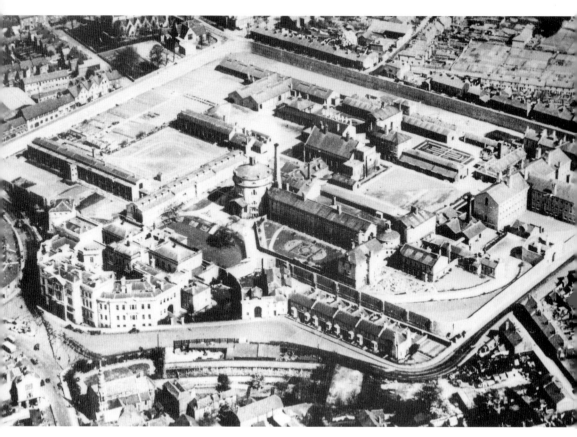

MAIDSTONE PRISON, WEEK STREET, photographed from the air *c.* 1930. The prison was built during the period 1810 to 1819, the architects being Daniel Alexander and John Whichcord Sen. It replaced the eighteenth-century County Prison and Bridewell in King Street, and the Town Prison. The Sessions House, designed by Sir Robert Smirke, was built in front of Maidstone Prison in 1827 and is now all but hidden by County Hall, built in 1913 from the designs of F.W. Ruck.

SECTION NINE

Sport and Entertainment

As the population of Maidstone increased facilities for sport and entertainment improved. Traditional sports like bear-baiting (which took place in the lower High Street) and cock-fighting (in East Lane, now King Street) gave way to more civilized forms of entertainment such as cricket, football, the theatre, the cinema, or Maidstone's zoo.

Maidstone has long been associated with cricket; the first County Match played in Maidstone was in 1777. The Mote Club and ground were established in 1857 and many famous cricketers played there. Maidstone Rugby Football Club is one of the oldest in the country, but records only go back to 1880. Maidstone United Football Club was formed about 1897 from the former Invicta Club. Both the Football and Rugby Football Clubs had their headquarters at the former athletic ground in London Road.

Probably Maidstone's most popular entertainment this century has been the cinema. In 1934 there were five cinemas in the town: the Empire, the Pavilion, the Central, the Palace and the Granada. The only one surviving is the Granada, which was severely damaged by floods in 1968 and has since been converted into a bingo club and three small cinemas.

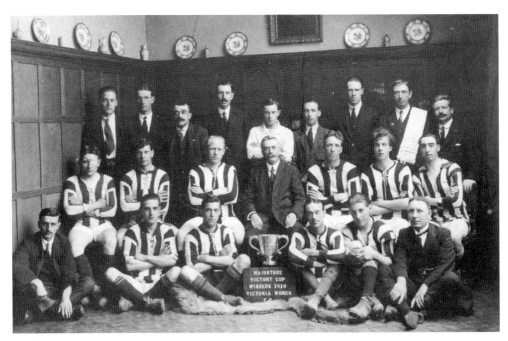

THE VICTORIA WORKS FOOTBALL CLUB (Tilling-Stevens) when they won the Maidstone Victory Cup for 1919.

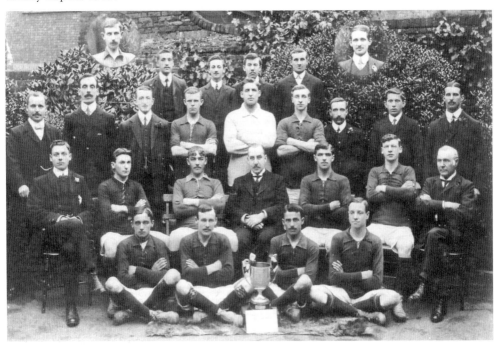

MAIDSTONE CENTRAL FOOTBALL CLUB (late Post Office Printing Works F.C.) were champions of Maidstone and District League Division II in 1907/8. The President, W.P. Dickenson, sits behind the trophy.

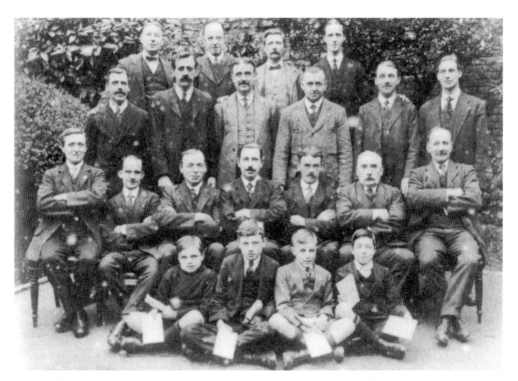

MAIDSTONE UNITED FOOTBALL SUPPORTERS' CLUB COMMITTEE 1919/20, H.E. Sharp (President). Back row, from left to right: W. Day, W. Headford, J. Ingram, H. Spell. Second row: G. Giles, L. Peters, F. Stretch, D. Tompsett, F. Hopkins, C. Bishop. Third row: E. McKee, F. Merricks, W. Giles, E. Leegood (Chairman), L. Binskin, C. Prichard, C. Johnson. Front row: M. Headford, E. Banner, W. Headford, F. McKee.

MAIDSTONE UNITED FOOTBALL CLUB'S MASCOT for the 1920/21 season.

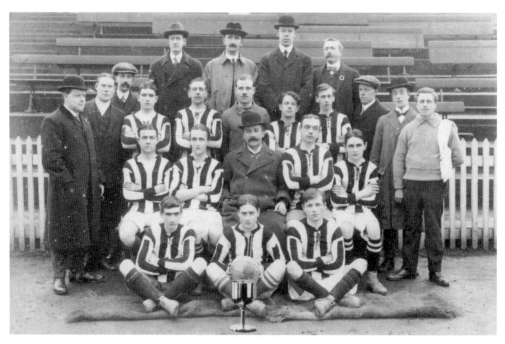

W.A. STEVENS LTD. XI, MAIDSTONE 1913/14. Committee, from left to right: F.T. Stace, E.V. Reeves, E. Leegood, E.A. Pearce, A.C. Gorham, E.A. Barnwell, A.G. Morton, A.A. Osborne, G.A. Goodwin, F.G. Lott (Trainer). Players: C. James, W.B. Griffith, R.C. Banks, A. Haywood, E.G. Freeman, S.H. Smith, C.W. Dodson, W.A. Stevens (president), S.T. Woodward, A.L. Eldridge, C.H. Carter, W. Day, C. O'Brien.

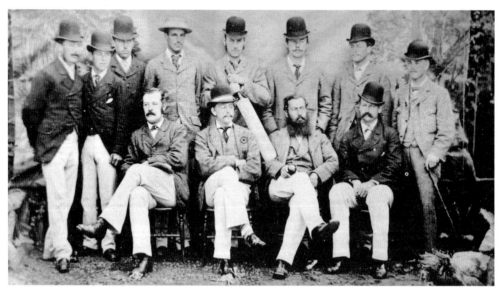

KENT CRICKET TEAM in 1876. Back row: E. Herty, G.G. Hearne, H.S. Thomson, W.B. Pattison, W.F. Kelery, F. Penn, F.A. Mackinnon, V.K. Shaw. Front row: W. Yardley, Lord Harris, C.A. Absolom, Capt. Fellowes.

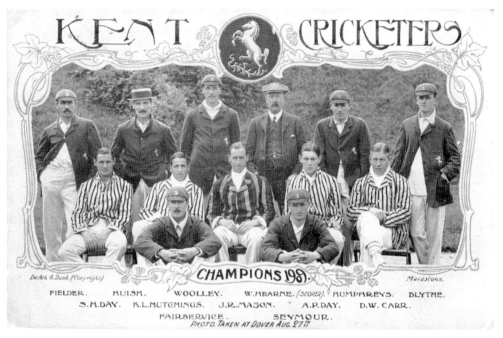

KENT CRICKET CHAMPIONS of 1909. Back row: Fielder, Huish, Woolley, W. Hearne (scorer), Humphreys, Blythe. Second row: S.H. Day, K.L. Hutchings, J.R. Mason, A.P. Day, D.W. Carr. Front row: Fairservice, Seymour.

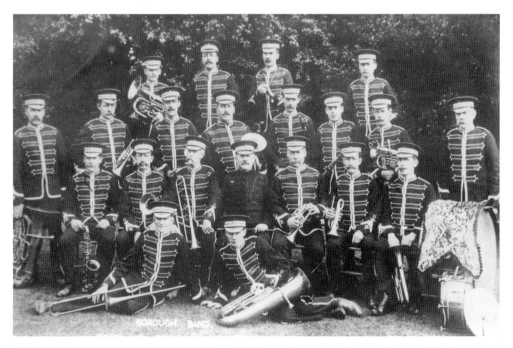

THE MAIDSTONE BOROUGH BAND in 1909, conducted by Henry Manning. The band was in regular attendance at football matches at the Athletic Ground in London Road.

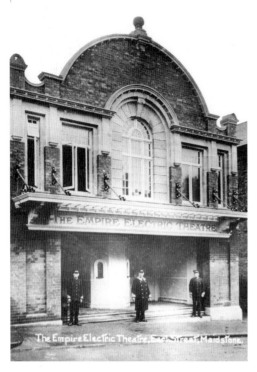

THE EMPIRE ELECTRIC THEATRE IN EARL STREET, opened on 11 February 1911, was designed by the County Architects, Messrs Ruck & Smith and was under the directorship of two local brothers, J.C. and W.H. Dunk. The cinema underwent three name changes: the Medina, the Wardona and finally the Regal. It closed on 18 May 1957 and the Trustee Savings Bank now occupies the site.

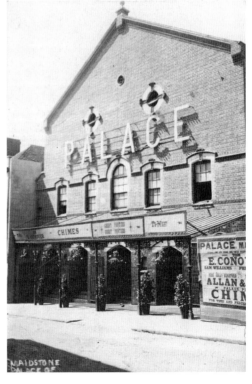

MAIDSTONE'S PALACE OF VARIETIES IN GABRIEL'S HILL was opened on 23 March 1908. Many celebrities, including Gracie Fields, Harry Lauder and Wilkie Bard, appeared at the theatre. Consistant financial losses in 1930/31 forced the management to turn to films, but provision was still made for live performances. The Palace closed on 19 October 1957 and afterwards J. Sainsbury Ltd. opened a shop on the site. The premises are now occupied by Robert Dyas Ltd.

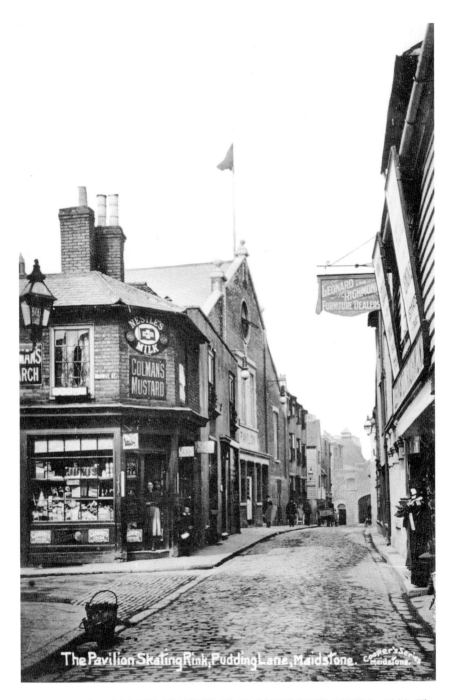

The Pavilion Skating Rink, Pudding Lane, Maidstone. Cooper & Sons, Maidstone.

THE PAVILION ROLLER SKATING RINK IN PUDDING LANE in 1909. The rink was later converted into the Popular Picture Pavilion, which opened on 18 March 1911, and was hailed at the time as 'Kent's largest super cinema', reputed to hold 2,000 patrons. It was later renamed the Ritz. The building was destroyed by fire in 1954 and Cornwallis House has since been built on the site.

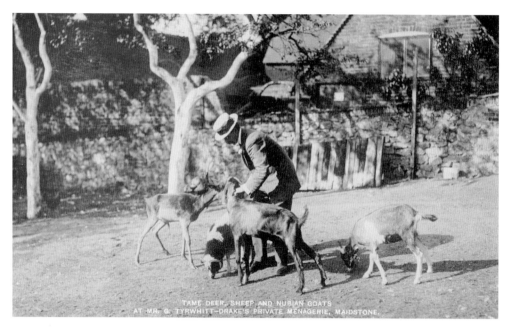

SIR GARRARD TYRWHITT-DRAKE with some of his animals at his private zoo at Cobtree Manor in 1912. At that time the animals were only shown occasionally in aid of local charities.

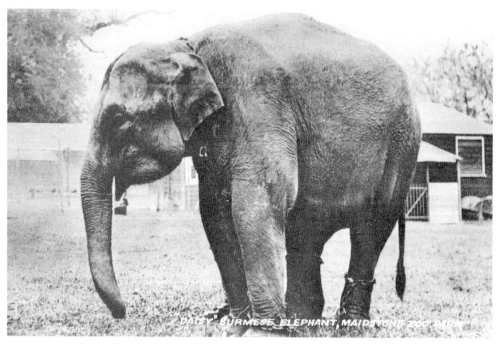

SIR GARRARD OPENED A PERMANENT ZOO at Cobtree in March 1934. Daisy was one of his Burmese elephants who, together with another elephant, Gert, was named by the two showbusiness personalities, Elsie and Doris Walters. The zoo closed in 1959, but the elephant house remains and has since been restored by the Cobtree Charity Trust.

SECTION TEN

Transport

The South Eastern Railway provided the first train service to Maidstone via a branch line from Paddock Wood on 25 September 1844 and the station was built at the far end of Hart Street. The line was extended to Strood in 1856, the present Maidstone West Station was built and the first station closed. Maidstone East Station came into operation when the London, Chatham and Dover Railway Company extended its system from Otford to Maidstone on 1 June 1874. The line was extended to Ashford in 1884.

Horse-drawn vehicles for passenger transport were still in operation in Maidstone in the early 1900s. The first municipal transport came into being in 1904 when the Corporation opened a tramway between the High Street in Maidstone and the Fountain Inn at Barming.

A motorbus service was introduced in 1924 from London Road (Queen's Avenue) to Penenden Heath and trolleybuses served the town from 1 May 1928 to 15 April 1967.

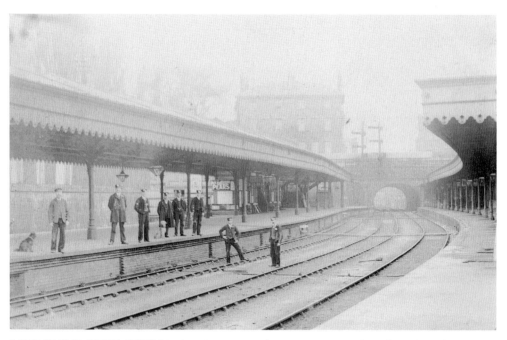

MAIDSTONE WEST STATION in 1900. Since this picture was taken there have been some changes, including electrification, modern lighting and the resiting of the footbridge.

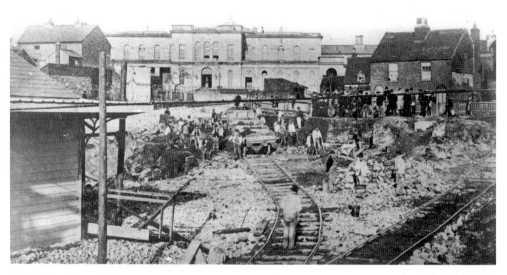

THE CONSTRUCTION OF THE LONDON, DOVER & CHATHAM RAILWAY at Maidstone East in 1874. The photograph shows the site of the station, with the Victoria Hotel on the right. In the background is the Sessions House, now obscured by County Hall.

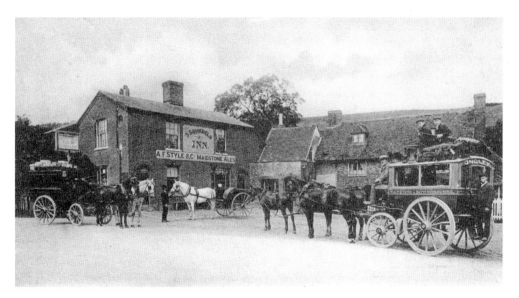

HORSE BUSES ON ONGLEY'S MAIDSTONE TO SITTINGBOURNE SERVICE meet at the Three Squirrels Inn at Stockbury *c*. 1903.

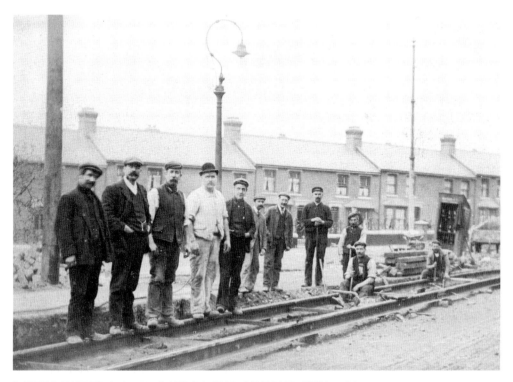

LAYING THE TRAM LINES AT THE TOP OF TOVIL Hill in 1907.

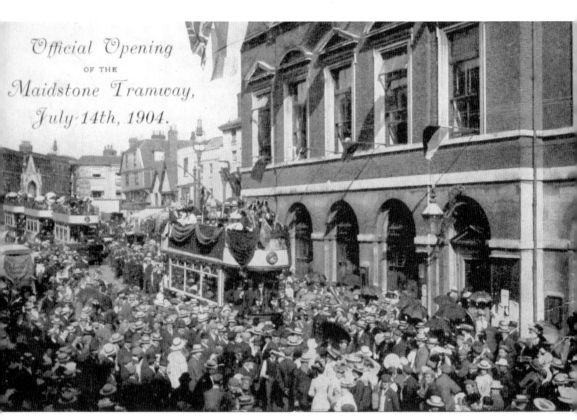

Official Opening
OF THE
Maidstone Tramway,
July 14th, 1904.

GREAT PUBLIC INTEREST WAS SHOWN when the Maidstone Corporation Tramway opened on 14 July 1904. The initial fleet consisted of six open-top trams built by the Electric Railway & Tramway Carriage Company. The trams had twenty-six seats outside and twenty-two inside and the livery was brown and ivory.

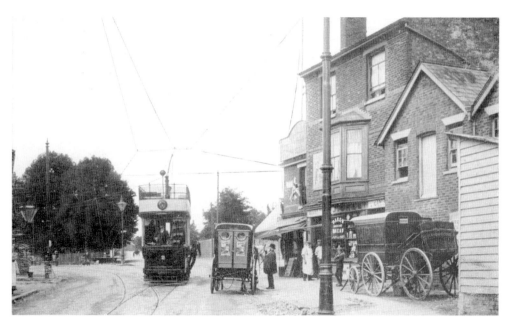

TRAM NO.2 LEAVING THE FIRST PASSING LOOP at the Queen's Road junction on its journey from Barming into town in 1904. Only a single track was built along Tonbridge Road with passing loops provided every quarter mile. The Tramways office and sheds were sited at this junction.

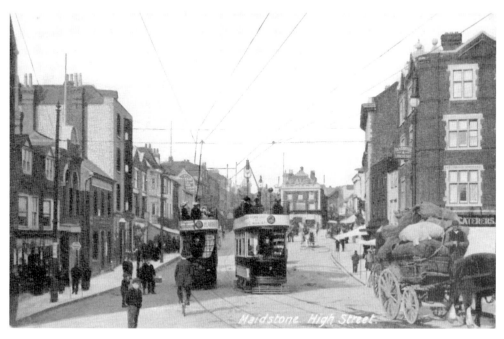

A SEVENTH TRAM WAS ADDED TO THE INITIAL FLEET in February 1905. It is seen here passing No. 5 at the lower end of the High Street.

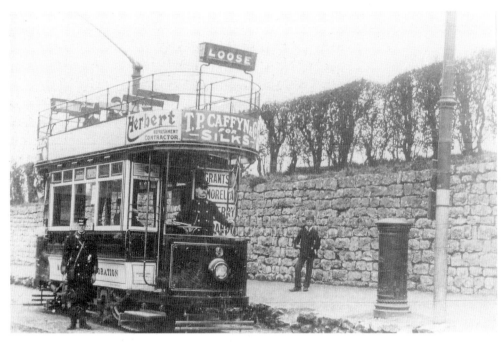

TRAM NO.9 WAITING at the Loose terminus in 1908. The Maidstone to Loose service opened on 16 October 1907, using eight vehicles built by United Electric.

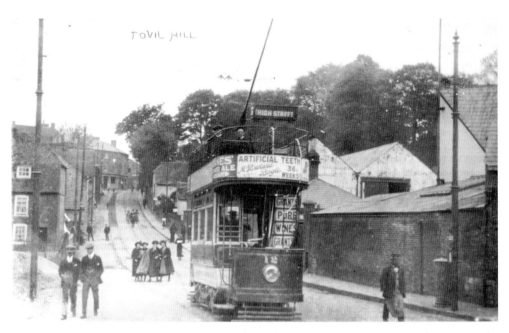

TRAM NO.12 ON ITS WAY UP THE HILL from the terminus at Rose Inn, Tovil in 1912. The service from High Street to Tovil was brought into operation on 9 January 1908.

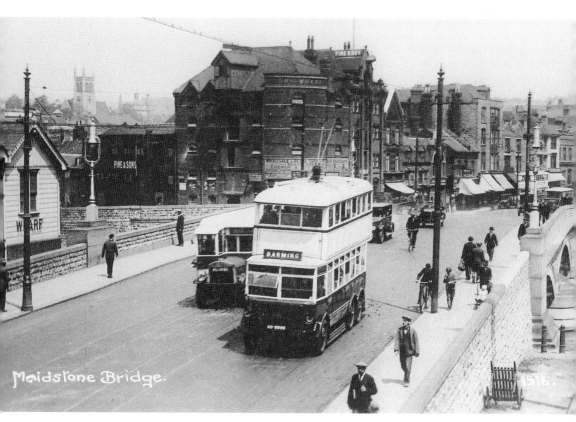

Maidstone Bridge.

ONE OF THE EIGHT RANSOMES TROLLEYBUSES that replaced the Barming trams on 1 May 1928. The Tilling-Stevens motorbus alongside operated on the London Road service. The Ransomes cost £2,005 each and gave reliable service until replaced in 1947. Two of the eight ended their days as staff rooms at Sir Garrard Tyrwhitt-Drake's zoo at Cobtree.

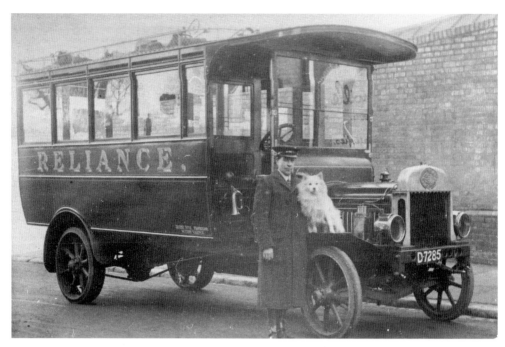

AN EARLY BUS OPERATOR IN MAIDSTONE was Ernest Neve, who traded as Reliance. He and his dog are seen here with one of his buses outside Maidstone East Station in 1912. Note the primitive motor horn. In 1916 Neve sold out to Maidstone & District Motor Services Ltd. (formed in 1911).

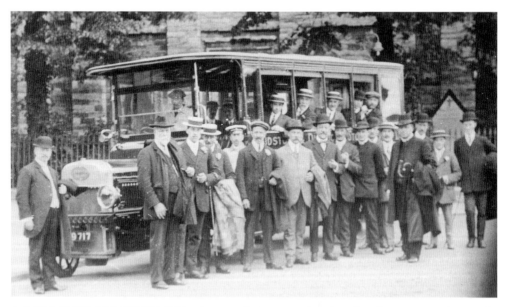

A MEN-ONLY BUS EXCURSION from Holy Trinity Church, Church Street, in 1914. The vehicle, D9717, was new to Maidstone & District Motor Services in May 1913 and was their first bus to have the famous green livery.

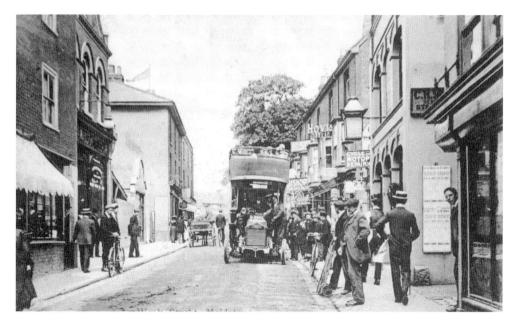

THIS HALLFORD 30 HP CHAIN DRIVEN BUS (D3944), photographed in Week Street in 1914, was built in 1908 for the Maidstone to Chatham bus service. The double-deck body was removed at night and a lorry body substituted so that the vehicle could convey fruit and hops to London.

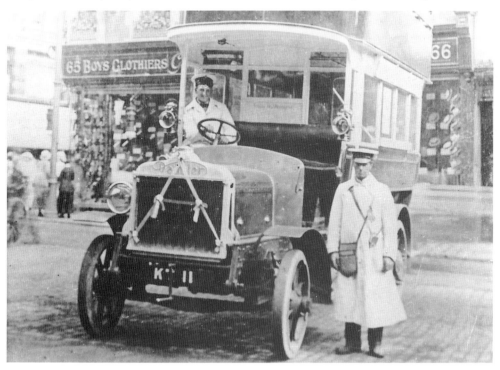

MOTOR BUS KT11, a red and white Daimler owned by Maidstone & District Motor Services Ltd., waiting outside Leavey's Outfitters in 1914.

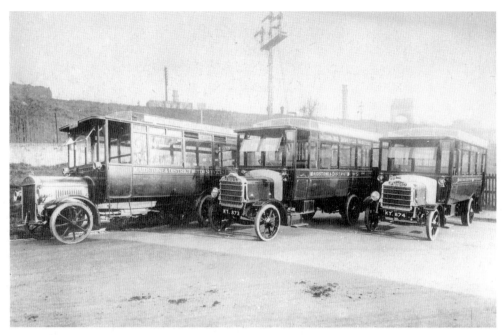

THREE EARLY BUSES, belonging to Maidstone & District Motor Services Ltd., photographed in their yard in St Peter's Street in 1914. The bus on the left was a green and red Tilling-Stevens; the other two were green Daimlers. Maidstone East railway line can be seen in the background.

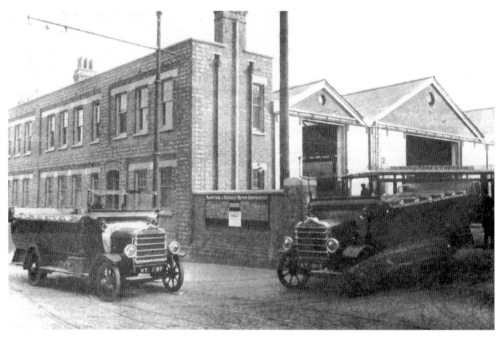

TWO DAIMLER CHARABANCS outside Maidstone & District's new bus depot in Upper Stone Street in 1914. The Company moved to Knightrider Street in 1928.

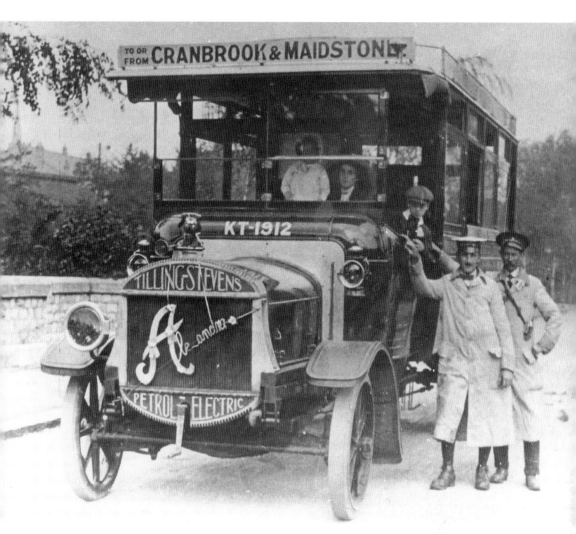

A NEW 40 HP BUS, one of eleven Tilling-Stevens petrol-electric vehicles delivered to Maidstone & District Motor Services Ltd. in 1914. It is seen here, on the Maidstone to Cranbrook service, waiting in Palace Avenue on Alexandra Rose Day, June 1914. Note the roses on the radiator.

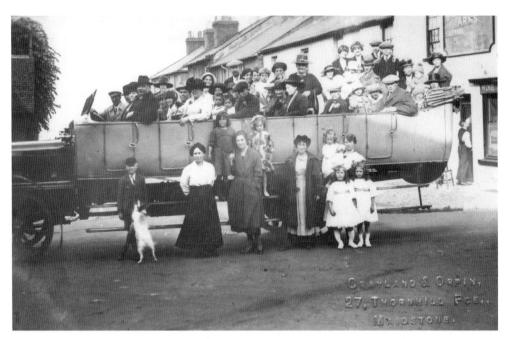

A CHARABANC EXCURSION FROM THE BRICKMAKER'S ARMS in Perryfield Street in the 1920s.

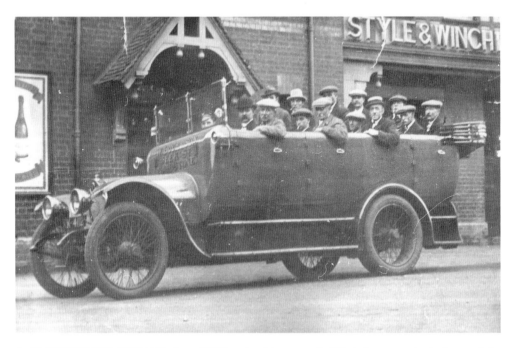

A CROSSLEY BUS (KK4112), from William Buck's garage in Week Street, waits in front of the Medway Brewery in St Peter's Street. Buck's fleet of eighteen grey-liveried vehicles was acquired by Maidstone & District Motor Services in 1929.

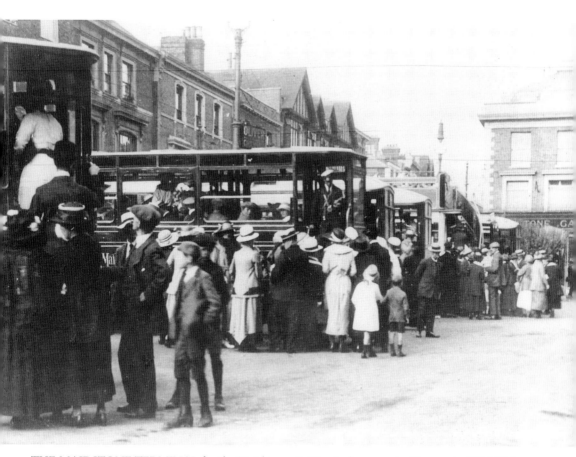

THE MAIDSTONE TERMINAL for the Maidstone & District buses at the Cannon in 1916. This was the main departure point for longer distance services until the bus station opened in Palace Avenue in 1922.

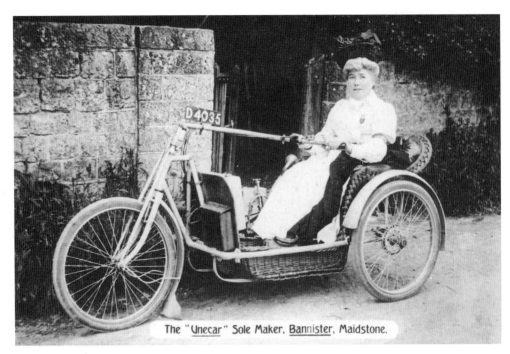

The "Unecar" Sole Maker, Bannister, Maidstone.

MRS WALTER BANNISTER demonstrating one of her husband's inventions in 1908. Bannister had a garage business at 62 King Street where between 1904 and 1910 he built several of these single seat three-wheelers under the name of 'Unecar'. The machine was exhibited at Olympia and subsequently marketed.

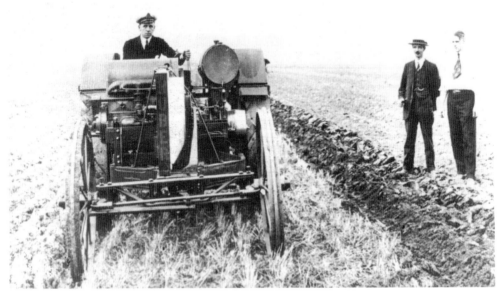

WILLIAM ROOTES in Royal Naval Volunteer Reserve uniform, testing an early Huber tractor at Maidstone during the First World War. His brother Reginald, in the straw hat, and an engineer watch the trial.

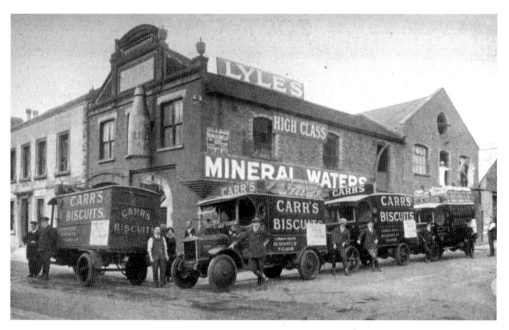

A BISCUIT DELIVERY, by Carr's of Fulham, to Lyle's Mineral Water Works in King Street in 1912. Lyle's distributed the biscuits to the local public houses when delivering their mineral waters. The 8ft ginger beer bottle on the front of the building was removed in 1938 as it had become a traffic hazard.

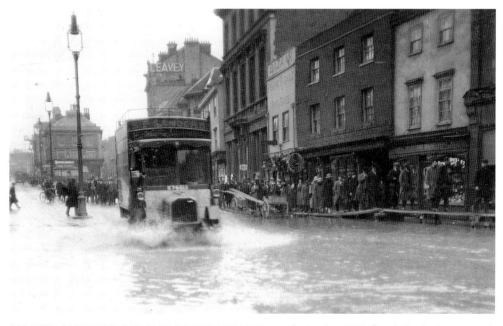

SAMUEL SANDERS' REMOVAL VAN (KT6615) caught in the 1927 floods in the lower High Street. Duckboards were erected above the pavements for the pedestrians.

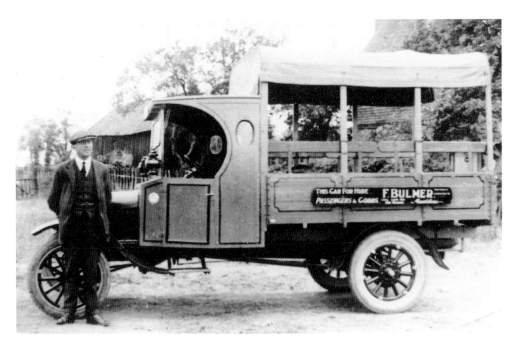

THIS MAIDSTONE 'LORRIBUS' of the 1920s doubled as a lorry for goods and a bus for passengers. The vehicle belonged to F. Bulmer of the Lamb Inn, Fairmeadow.

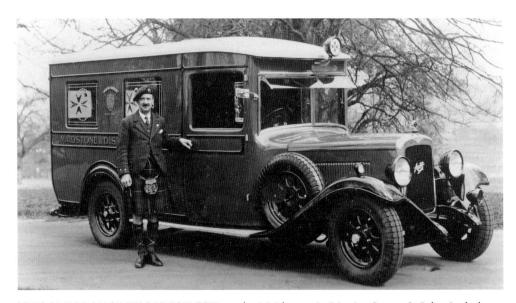

THIS AMBULANCE WAS PRESENTED to the Maidstone & District Corps, St John Ambulance Brigade, by the Marquis Camden on Whit Monday 1932. The vehicle was provided by the 'Keg Megs', the younger readers of the *Kent Messenger*, from the proceeds of their annual Keg Meg Fête, and collecting waste paper and silver paper. The chief of the Keg Megs, 'Kousin Mac', stands by the ambulance.

SECTION ELEVEN

Parks and Gardens

The first parks in Maidstone were privately owned. These included the Archbishop's Park, meadowland on the opposite side of the river to the Palace and Mote Park, the park around Mote House which belonged to the Earls of Romney and subsequently Lord Bearsted.

In the nineteenth century Maidstone Corporation acquired at least four parks and gardens. Brenchley Gardens, which adjoin Maidstone Museum and are sited on the former St Faith's Green, were presented to the town by Julius Brenchley in 1873. A portion of the once notorious Penenden Heath was enclosed as a recreation ground for the town in 1881. Cornwallis Playground in Tonbridge Road was the gift of Herbert Monckton in 1895 and Palace Gardens were purchased with the Archbishop's Palace in 1887. Palace Gardens were enlarged in 1904 with the addition of the grounds of Church Mill after its demolition in 1902. The size of the Gardens was drastically reduced again when Bishop's Way was built in 1964.

During the twentieth century more public parks and recreation areas have been established, including Clare Park in Tonbridge Road which was presented to the town by Sir Edward Sharp Bt. in 1923, and Mote Park which was purchased by the Council from Lord Bearsted in 1929.

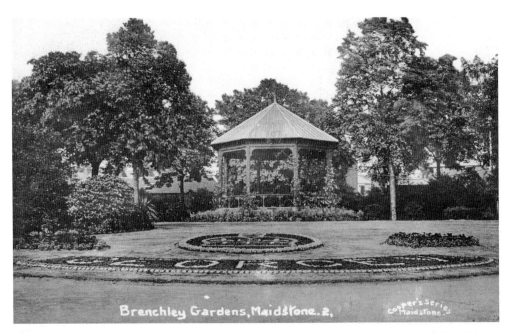

THE FLOWER BEDS IN BRENCHLEY GARDENS were laid out with red, white and blue flowers to form a large crown and the letters GEORGE V for the King's Coronation on 22 June 1911.

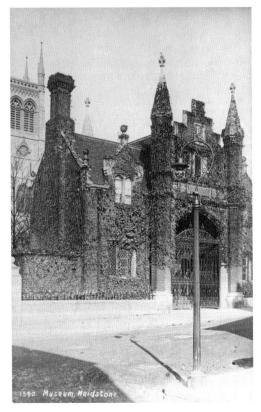

THE ORNATE GATEWAY TO BRENCHLEY GARDENS pictured about 1900. The gateway was badly damaged by enemy action on 27 September 1940 and the adjoining cottage was reduced to rubble. A bomb also fell near St Faith's Church, splitting the clock tower from top to bottom.

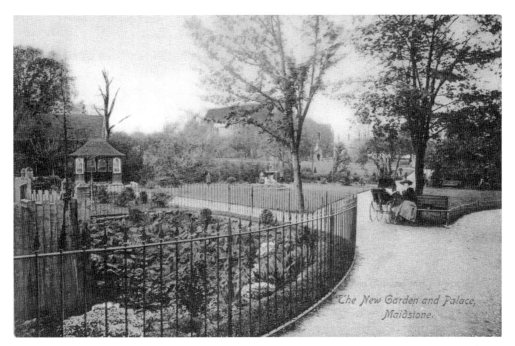

THE NEW EXTENSION TO PALACE GARDENS, opened 20 July 1904.

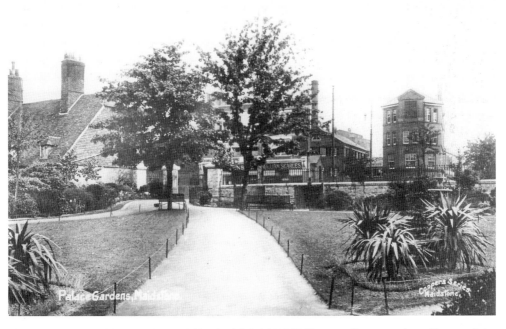

THE MILL STREET ENTRANCE TO PALACE GARDENS was adjacent to the mill-race of the former Church Mill. The mill-race exists today in Bishop's Way. Note the old tannery buildings that were taken over by Rootes.

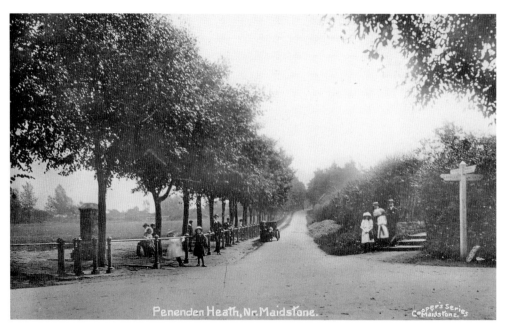

THE RECREATION GROUND, PENENDEN HEATH, photographed *c.* 1908. Prior to 1830 the gallows stood to the south of the Heath. They were subsequently erected at the side of the Porter's Lodge in front of Maidstone Prison.

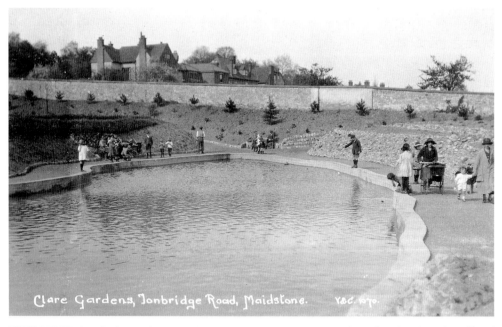

THIS VIEW OF CLARE PARK IN TONBRIDGE ROAD was taken shortly after the official opening by Sir Edward Sharp's wife on 25 April 1923. Lady Sharp unveiled a plaque and named the newly created park after herself. After the opening ceremony Lady Sharp and Sir Edward planted two commemorative trees in the park.

SECTION TWELVE

Military Matters

During the wars of the eighteenth century troops were frequently encamped at Coxheath, a tract of heathland situated about three miles south-east of Maidstone. The last encampment on the Heath was in 1804.

In 1797 barracks for the cavalry regiments serving in India were built in Sandling Road, Maidstone. An Act of Parliament had to be passed for the purchase of this land which had been a hop garden. The Barracks have since been occupied by the Queen's Own Royal West Kent Regiment. Many of the Regiment's colours have been laid up in All Saints' Church and the Regimental Museum is housed in Maidstone Museum. In March 1961 the Queen's Own Royal West Kents were amalgamated with the Royal East Kent Regiment (the Buffs), to form the Royal Kent Regiment (the Queen's Own Buffs). The regiment now has the freedom of the Borough of Maidstone.

At the outbreak of the Second World War, Park House and its grounds were requisitioned by the government for use as an army barracks for the Royal Engineers.

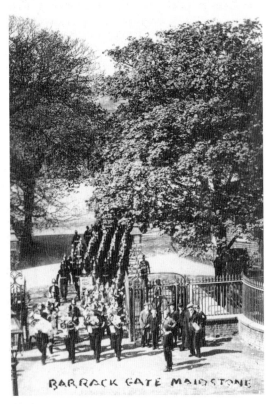

OFFICERS, MEN AND BANDSMEN of the Queen's Own (Royal West Kent) Regiment entering the town from the barracks in Sandling Road in 1904.

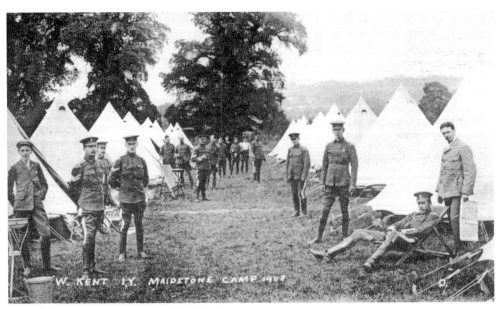

THE WEST KENT YEOMANRY in camp at Maidstone in 1905.

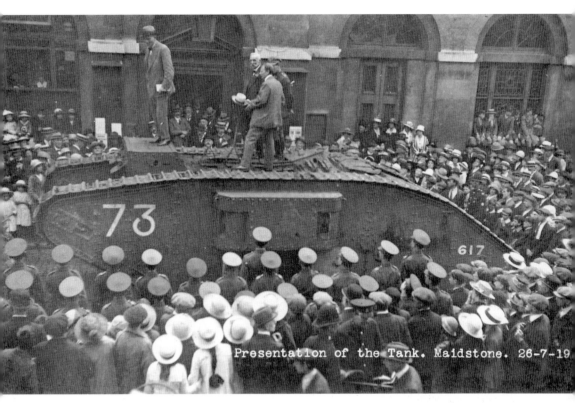

Presentation of the Tank. Maidstone. 26-7-19

MOST OF THE LARGER TOWNS IN KENT which had made a significant contribution to War Savings between 1914 and 1918 were presented with a tank. This photograph was taken at the handing over ceremony of Maidstone's First World War tank, No. 73, on 26 July 1919. The tank stood by Maidstone Bridge until 1927, when it was moved to Brenchley Gardens. It was finally broken up for scrap during the Second World War; the only surviving tank in Kent is at Ashford.

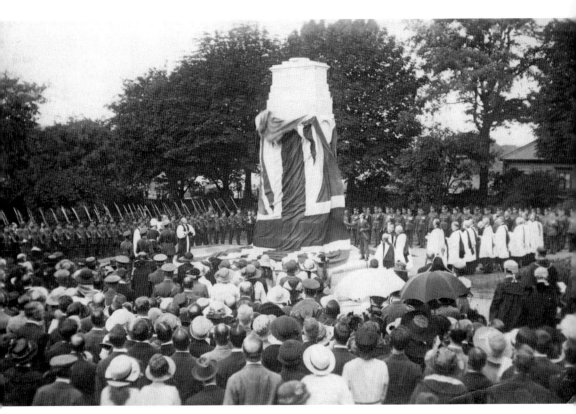

THE UNVEILING OF THE CENOTAPH IN BRENCHLEY GARDENS on 30 August 1921.
The memorial was erected to 'The glorious dead of the Queen's Own Royal West Kent Regiment
1914–1918' and was designed by Sir Edward Lutyens, the architect of the Whitehall Cenotaph.
On the same day the regiment's colours were laid on the altar of the All Saints' Church and a
bronze plaque on the north wall of the church was dedicated to the regiment by the Archbishop
of Canterbury.

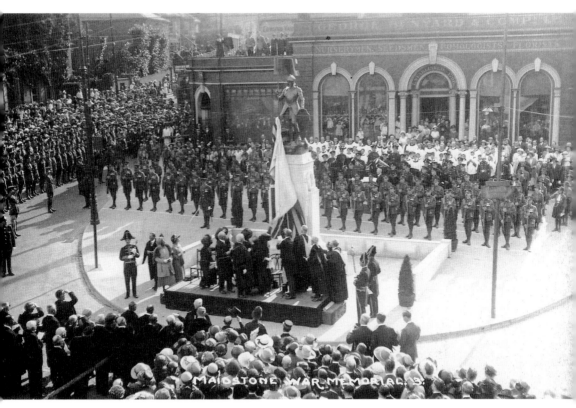

THE UNVEILING OF THE WAR MEMORIAL IN THE BROADWAY on 21 June 1922. The inscription on the monument reads 'In honour of our glorious dead who gave their lives in the Great War, for ever honoured and for ever mourned. 1914–1918'. After the Second World War '1939–1945' was added. The bronze figure of St George and the dragon was designed by Sir George Frampton RA.

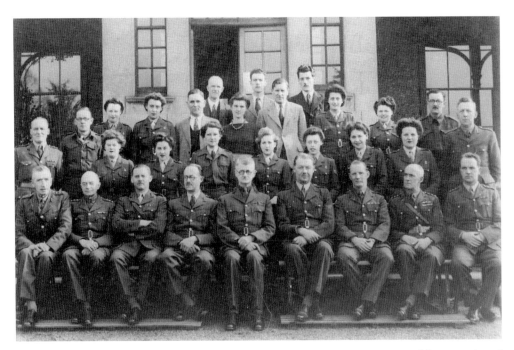

COLONEL R.H. HOUNSELL, Chief Engineer, East Kent District (in centre of front row) and members of his staff outside Foley House when it was requisitioned by the army during the Second World War. This photograph was kindly loaned by John Philps, third from the left in the third row back.

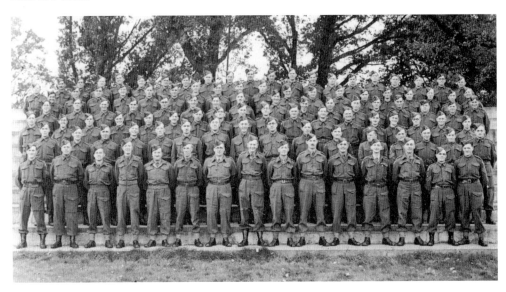

MEMBERS OF MAIDSTONE'S HOME GUARD photographed at the Athletic Ground in London Road at the end of the Second World War. Included in the picture are Capt. Harris, Sgt. Bert Roberts, Sgt. Bert Ashdown, Henry Darley, Jim Rogers, Harry Funnell, Stuart Murray and William Bailey.

SECTION THIRTEEN

Public Events
and Celebrations

As one might expect of the county town of Kent, Maidstone was the scene of many public events such as royal visits, ceremonial processions, etc., which attracted crowds of spectators, some of whom travelled quite long distances to be present. The local photographers were not slow in identifying and catering for the souvenir market which this created and produced, in a matter of hours, postcards depicting the event. The contemporary craze for sending and collecting postcards, of which over 600 million were delivered in 1903/4, was probably an incentive to photograph as many events as possible. As a result we have been left an invaluable record of the times.

One thing has not changed over the years: a big event in Maidstone still brings the traffic through the town to a halt.

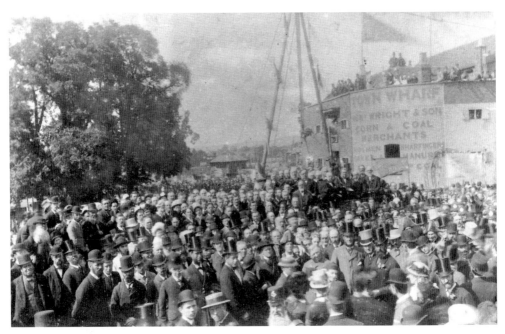

THOUSANDS OF SPECTATORS attended the opening of the 'new' Maidstone Bridge on 6 August 1879. Note the old Town Wharf and the row of elm trees in Fairmeadow.

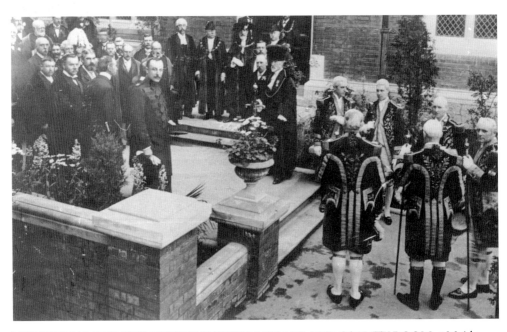

THE FORMAL OPENING OF THE VICTORIA LIBRARY AND COUNTY ROOM at Maidstone Museum on 23 June 1899. The ceremony was conducted by the Lord Mayor of London.

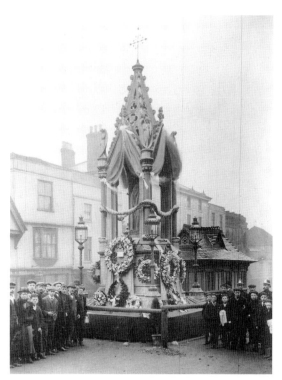

QUEEN VICTORIA'S STATUE IN THE HIGH STREET was adorned with memorial wreaths after her death on 23 January 1901.

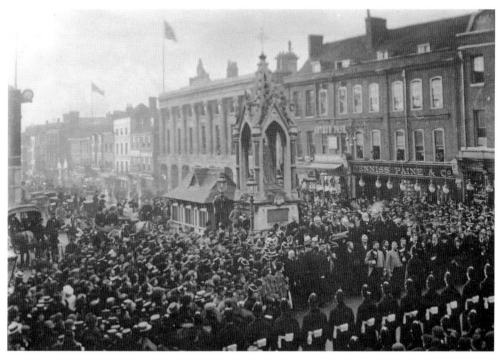

THE PROCLAMATION OF THE ACCESSION OF KING EDWARD VII was read by F. Josiah Oliver, Mayor of Maidstone, at the top of the High Street on 25 January 1901.

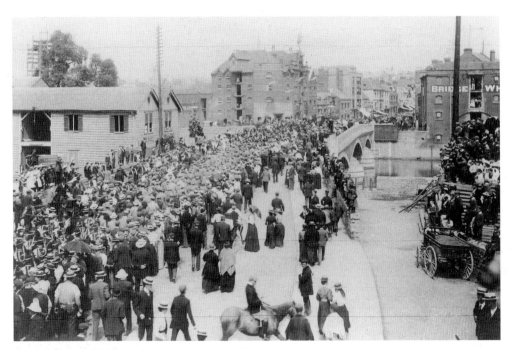

THE HOMECOMING OF THE WEST KENT YEOMANRY on 19 July 1901 from the Boer War in South Africa. At the top left of the picture the newly-erected chimney of the Electricity Works can be seen.

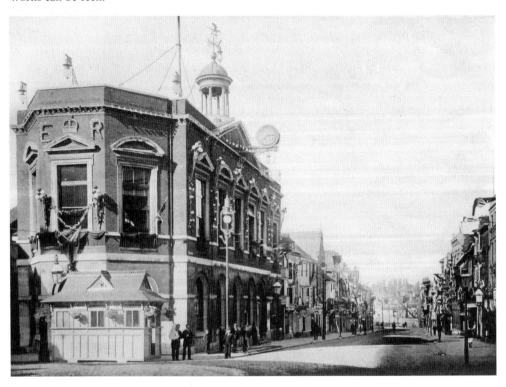

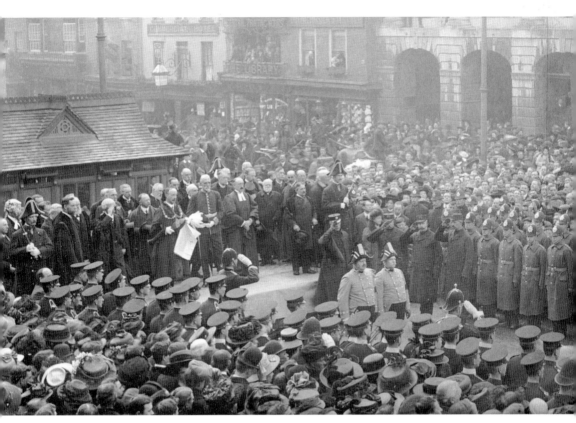

THE MAYOR OF MAIDSTONE, J. Raynor Betts, read the proclamation of the accession of King George V outside the town hall on 9 May 1910. Among those present were the High Sheriff of Kent, Robert Norton JP, DL (on the Mayor's left), members of Maidstone Council and Chief Constable Mackintosh of the County Police. Detachments of the Royal West Kent Regiment from the Barracks in Sandling Road formed three sides of a square in front of the platform.

Left (bottom): THE TOWN HALL, decorated for the coronation of Edward VII on 9 August 1902. The cab shelter in the foreground was removed many years later and re-erected as a summer house in the grounds of Linton Hospital.

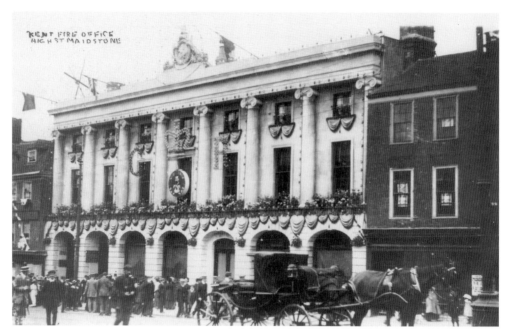

KING GEORGE V'S CORONATION DAY on 22 June 1911, The Kent Fire Office in the High Street was decorated with purple and gold bunting and red, white and blue flowers. A picture of the King formed the centrepiece.

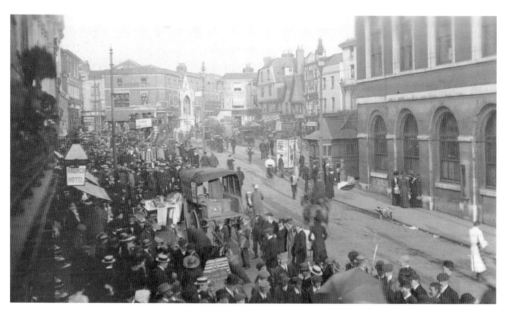

FAIR DAY IN THE HIGH STREET in October 1914, The October Fair was always popular, with swings, roundabouts and side shows in Fairmeadow and market stalls along the High Street. Note the four-sided wheeled handcart by the cab shelter, advertising forthcoming attractions at the Palace Theatre.

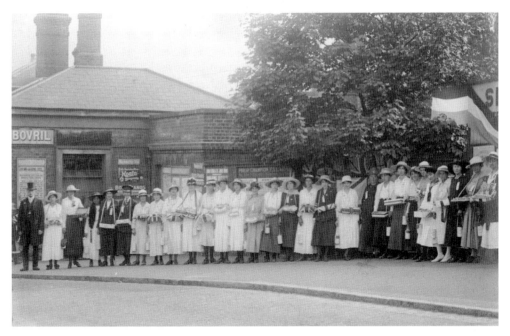

FLAG DAY FOR THE RAILWAY BENEVOLENT FUND on 11 June 1918. The stationmaster, railway staff and volunteers line up for the photograph in front of Maidstone West Station.

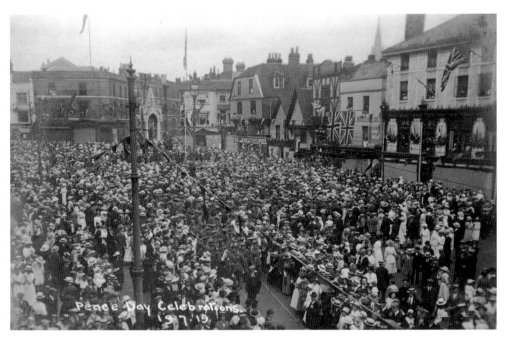

A HUGE CROWD ASSEMBLED IN THE HIGH STREET for the Peace Day celebrations on 19 July 1919. The Mayor, Alderman George Foster Clark, read the Declaration of Peace.

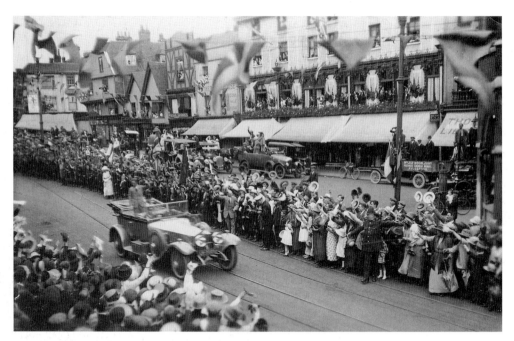

THE PRINCE OF WALES, later to become King Edward VIII, passed through Maidstone on 27 July 1921 on his way to open the Industrial Settlement for Ex-Servicemen at Preston Hall.

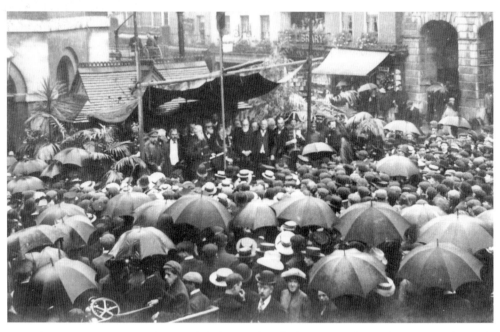

DESPITE THE RAIN, crowds attended this unidentified event in the High Street in the early 1900s. Potted palms were placed by the cab shelter and an awning was erected to protect the dignitaries from the weather. In the foreground of the photograph is an open top car and a tram is just visible beyond the town hall.

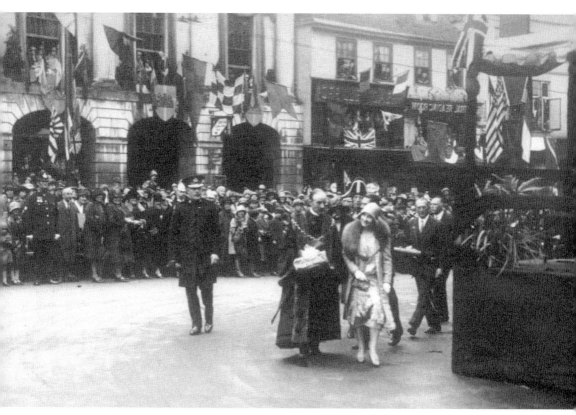

THE DUCHESS OF YORK (the late Queen Mother), with Sir Garrard Tyrwhitt-Drake, on the occasion of her visit to Maidstone with the Duke of York, on 8 June 1929. The Duke and Duchess received a loyal address at the town hall, inspected 2,000 girl guides at Lockmeadow and visited Mote Park, Preston Hall and British Legion Village.

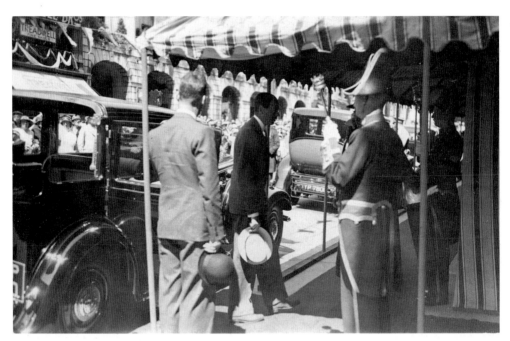

THE DUKE OF KENT, YOUNGEST SON OF KING GEORGE V, visited Maidstone and the County Show on 26 June 1935. He is seen here entering the Town Hall. This was his first official visit to the county after receiving his title from the King. His wife, Princess Marina, was to have accompanied him but was indisposed.

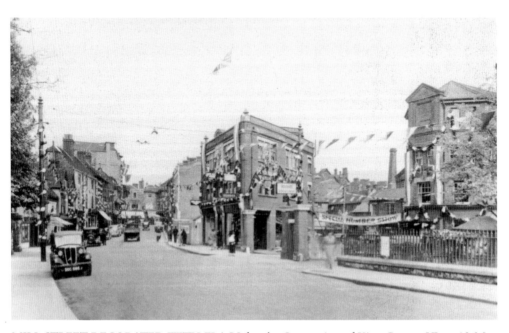

MILL STREET DECORATED WITH FLAGS for the Coronation of King George VI on 12 May 1937. Note Rootes' former showroom in the centre and the old tannery building on the right.

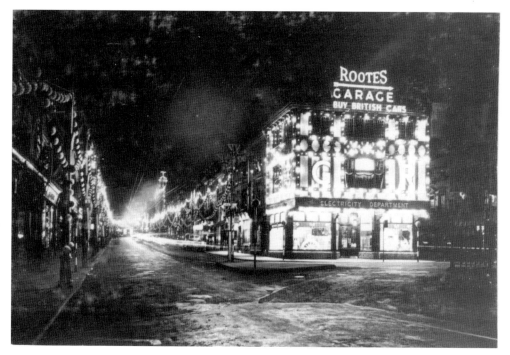

THE ELECTRICITY SHOWROOM at the western end of Middle Row, decorated for the Coronation of King George VI. The illuminations were some of the most spectacular in the town.

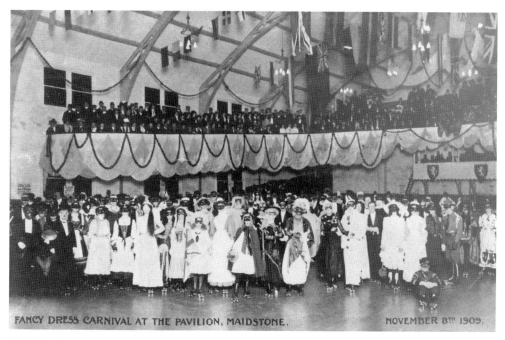

FANCY DRESS CARNIVAL AT THE PAVILION, MAIDSTONE. NOVEMBER 8TH 1909.

CARNIVAL NIGHT at the Maidstone Pavilion Roller Skating Rink, Pudding Lane on 8 November 1909.

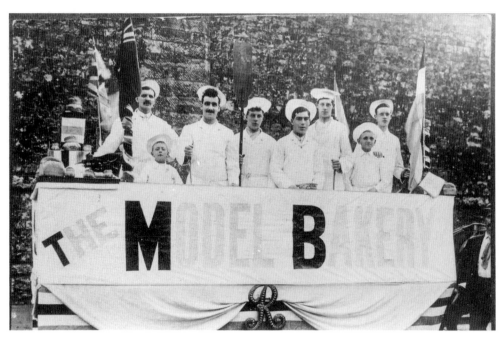

THE 'MODEL BAKERY' FLOAT WAITS under the prison wall for the start of the Maidstone Carnival procession in July 1910.

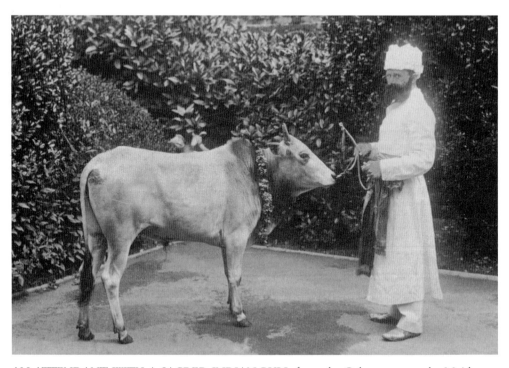

AN ATTENDANT WITH A SACRED INDIAN BULL from the Cobtree zoo at the Maidstone Pageant for Cricket Week in July 1912. The entry won first prize in the pedestrian class.

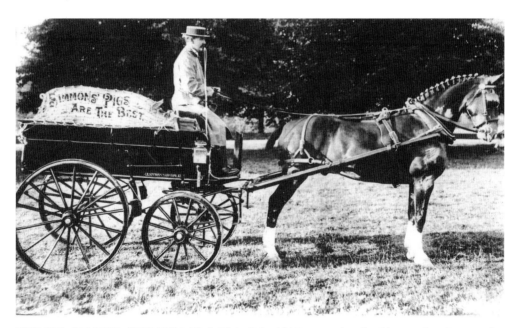

THE PIG ON THIS CARNIVAL FLOAT in July 1915 was printed with an advertisement for Charles Simmons of Little Buckland Farm.

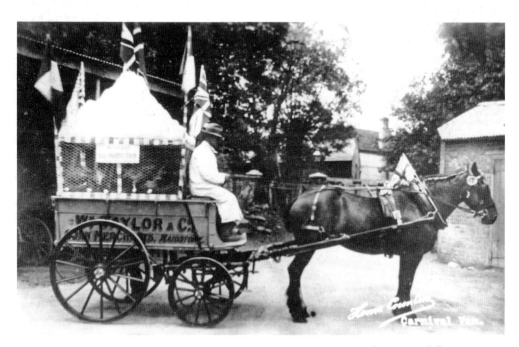

'INCREASE YOUR EGG PRODUCTION' WAS THE SLOGAN on this carnival float in 1919. The van belonged to William Taylor, miller and corn merchant, of 69 Bank Street.

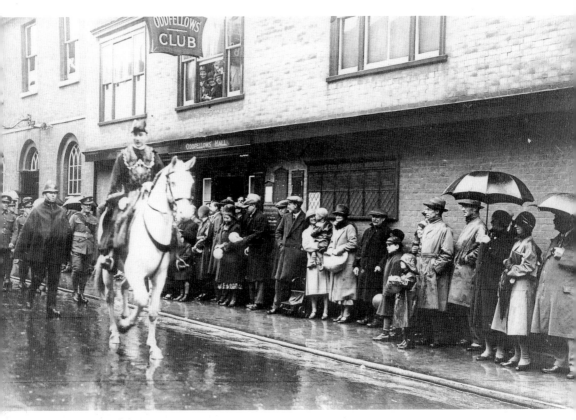

SIR GARRARD TYRWHITT-DRAKE, mounted on one of his famous cream stallions, rode at the head of the Mayor's Procession in King Street on 10 November 1928. Sir Garrard was Mayor of Maidstone twelve times between 1915 and 1949.

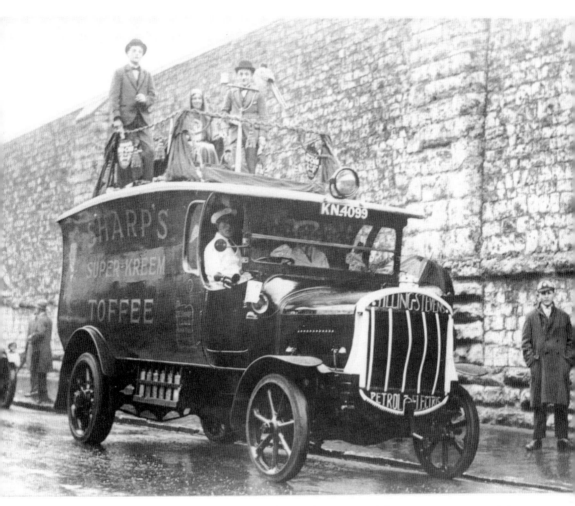

SHARP'S ENTRY FOR THE MAIDSTONE CARNIVAL in 1931. The two men on top of the van were dressed as Sir Kreemy Knut, the dapper individual with the bowler hat, monocle and walking stick, used by Edward Sharp & Co. as an advertising symbol. The macaw, similar to the one featured in their trademark, was one of many owned by the company and, between events, housed in Maidstone Zoo.

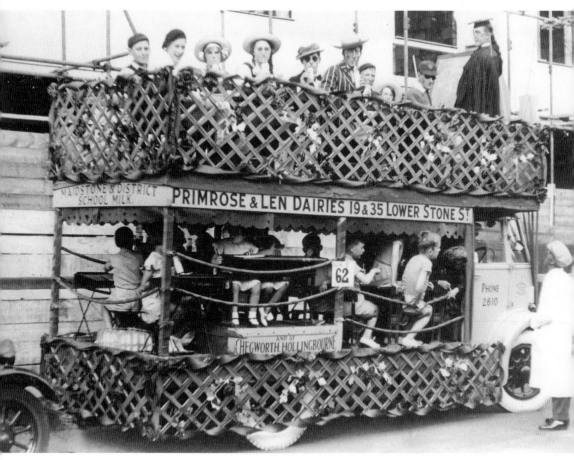

PRIMROSE & LEN DAIRIES' CARNIVAL FLOAT outside County Hall in 1934. On the top
deck are, from left to right: Jock Blythe, B.A. Ball, Bessie Still, Ethel Bentley, George Dodd, Tom
Quinell, Bob Hensby, Joyce Dooley, Len Jackson and Edgar Firmin. Below is Charles Sharp.

SECTION FOURTEEN

Disasters

Maidstone was not without its share of accidents and disasters, all of which were recorded by the ever alert photographer who was usually the only one to profit from the occurrence. Situated as it is on the River Medway, the town has seen some notable floods, which severely disrupted communications and in December 1927 caused the town's electricity supplies to be cut off. The electricity works in Fairmeadow were surrounded by water and the workers isolated within were supplied with provisions by breeches-buoy.

Shops, churches and breweries were among the buildings which suffered fires. Communication difficulties caused calls for the Fire Brigade to take longer than is the case in modern times and before the purchase in 1914 of Maidstone's first mechanically-propelled fire engine it was necessary to commandeer and harness the horses to the machine.

As one might expect, considering the traffic density at the time, road accidents in the period covered by these photographs occurred much less frequently than we are, unfortunately, used to today. However, the vehicles involved were usually heavy petrol or steam-powered vehicles; as a result, the infrequency of the accidents was more than outweighed by their spectacular nature.

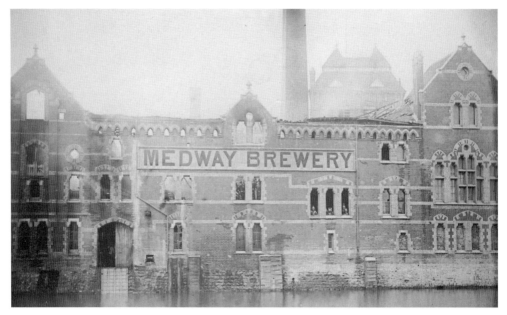

A FIRE AT A.F. STYLE'S MEDWAY BREWERY IN ST PETER'S STREET on the evening of Sunday 1 April 1894. It took about three hours for the Kent Fire Office, the Maidstone Volunteers and Hobbs' brigades to bring the fire under control, by which time £10,000 of damage had occurred. In 1899 A.F. Style amalgamated with E. Winch of Chatham; the firm of Style & Winch later became part of the Courage, Barclay & Simonds group. The Medway Brewery was demolished in 1975.

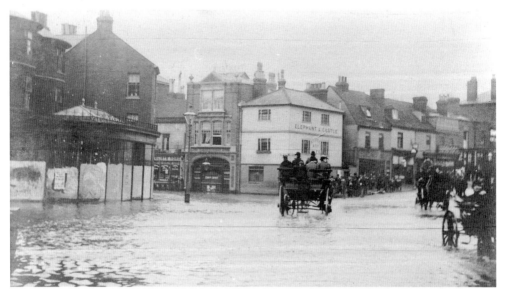

THE FLOOD IN THE BROADWAY AND HART STREET, 17 February 1900. The level, as recorded on the flood post in Waterside, was one of the highest on record. The post is now in Maidstone Museum.

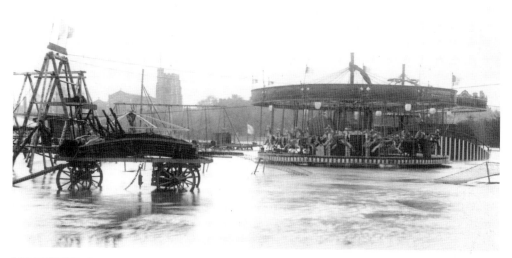

MR PETTIGROVE'S 'WORLD FAIR' IN LOCKMEADOW in the October floods of 1909. The caravan dwellers managed to escape to Barker Road and the horses were moved to higher ground, but the amusements had to be left to their fate.

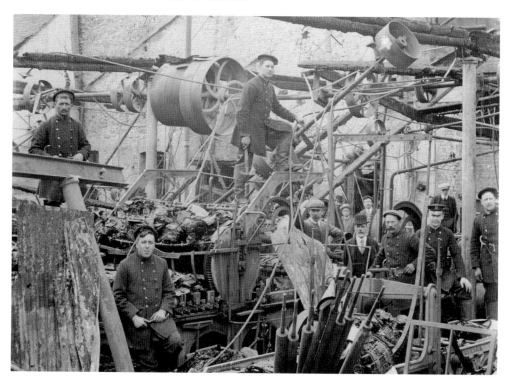

THE FIRE AT HOBBS PRINTING WORKS in Lower Stone Street on 11 June 1910. This view shows William Hobbs (in bowler hat) and the firemen inspecting the £30,000 worth of damage caused by the fire.

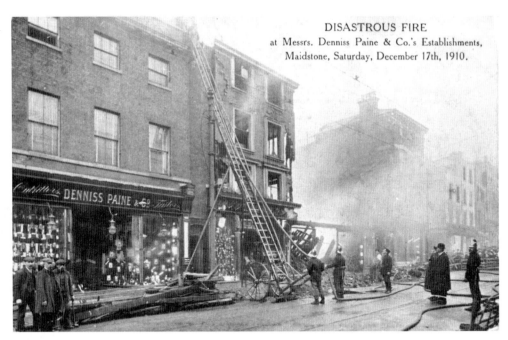

DENNISS PAINE & CO.'S PREMISES, on the corner of Pudding Lane and High Street, were severely damaged by a fire on Saturday 17 December 1910. Tragically a boy of fourteen died in the fire, his body being found in the ruins the following day.

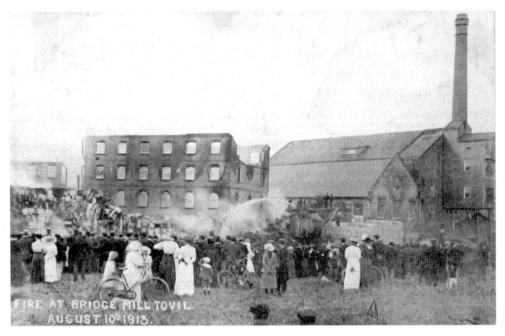

CROWDS OF SPECTATORS WATCHED THE FIRE which caused £30,000 worth of damage to Bridge Mill, Tovil, on 10 August 1913. This mill, which had always been prone to disaster, suffered another major fire on 19 October 1925 which resulted in many employees losing their jobs.

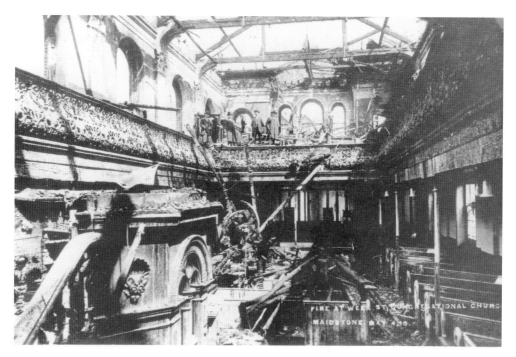

THE CONGREGATIONAL CHURCH IN WEEK STREET caught fire on 4 May 1915 and was so severely damaged that it had to be rebuilt.

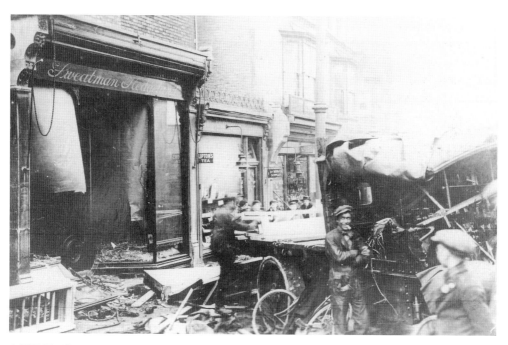

A RUNAWAY LORRY WHICH CRASHED IN THE BROADWAY in 1916. It is doubtful whether Messrs Sweatman & Hedgeland welcomed the unplanned alterations to their shop front.

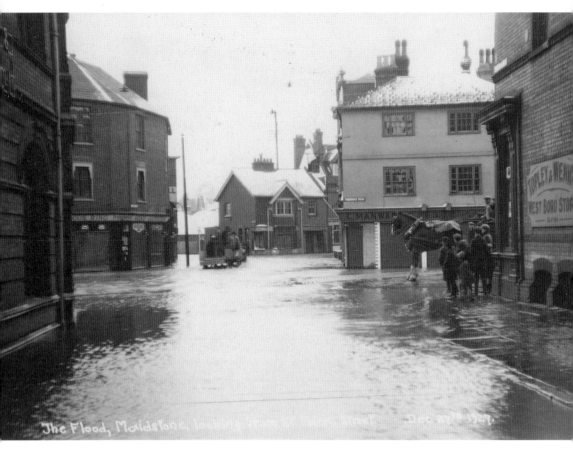

The Flood, Maidstone, looking from ... Street. Dec 27 1927

FLOODS IN ST PETER'S STREET AND HART STREET on 27 December 1927. The only means of reaching the town centre from Westborough was by horse and cart.

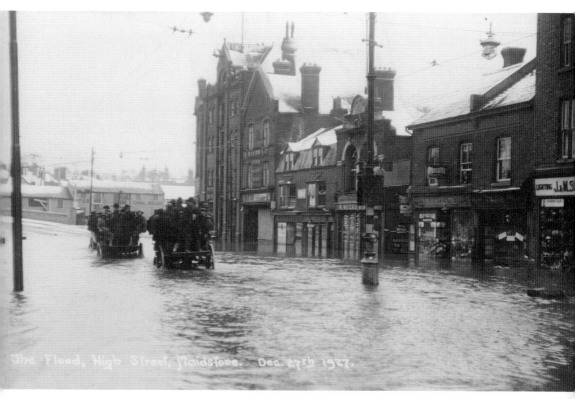

The Flood, High Street, Maidstone. Dec. 27th 1927.

TWO LADEN CARTS CROSSING MAIDSTONE BRIDGE during the 1927 floods. Trams and buses stopped either side of the bridge and passengers alighted, crossed by cart, then boarded other trams or buses on either side.

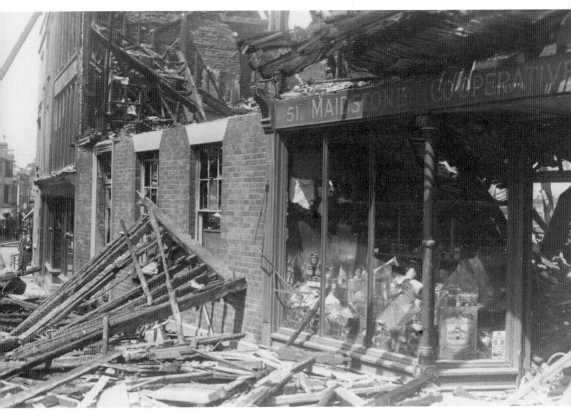

THE FIRE AT THE LOWER STONE STREET PREMISES of the Maidstone Co-operative
Society on 28 June 1929. The fire started above the ovens in the bakehouse, and the grocery store,
warehouse, offices, Co-op Hall and bakehouse were completely gutted. Two other properties,
William Hobbs & Sons' printing works and the White Lion public house, were also damaged.

SECTION FIFTEEN

The Hop-Pickers

The colourful hop-picking industry around Maidstone in the nineteenth and early twentieth centuries encouraged the contemporary photographers to capture many delightful studies in the hop gardens.

Hops have been grown in Kent for centuries and when the hop growing boom was at its height *c.* 1900, farmers employed about a quarter of a million casual workers for the picking. Most of these pickers came from London; every September families would leave the capital, usually by one of the special 'hopper' trains, to spend three or four weeks in the hop gardens. They brought most of their belongings with them to set up 'home' in the accommodation provided by the farmers. Hopping became their annual holiday and the same families returned to Kent year after year, often returning to the same hut.

There were also the gypsies and travellers, who did casual work as well as hop-picking, and the local inhabitants who were pleased to earn some extra money. Even school holidays were arranged to coincide with the hop-picking season so that children could pick with their mothers.

All this was to change after the Second World War when hop-picking became mechanized and fewer people were required in the gardens.

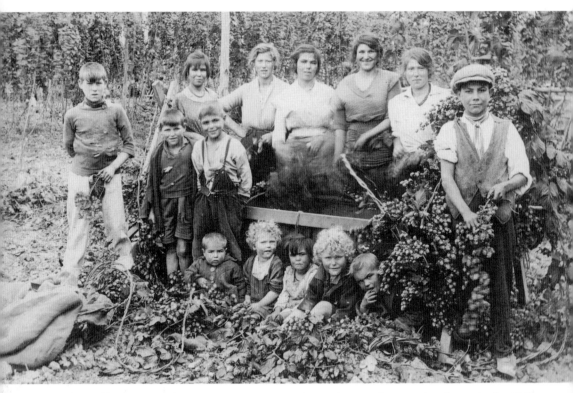

A GROUP OF PICKERS POSING BY THEIR BIN in a hop garden near Maidstone in the 1920s.

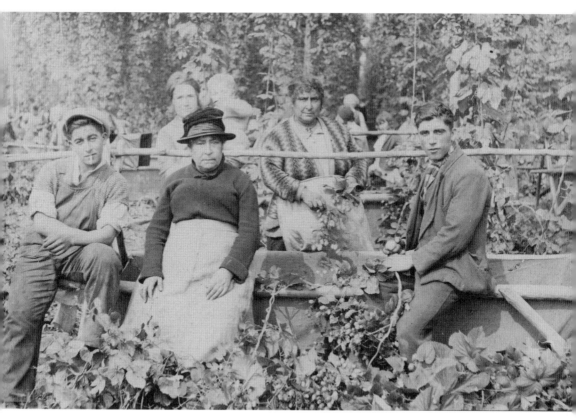

AGE WAS NO BARRIER. Young and old alike joined in the picking and the occasional well-earned break was welcome.

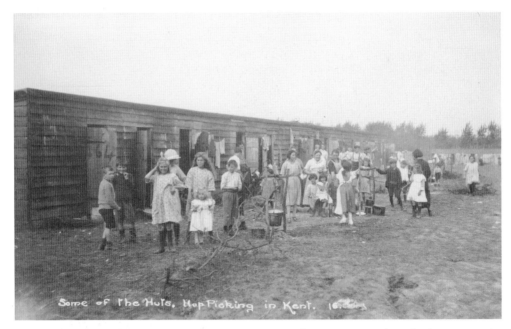

PICKERS' HUTS NEAR MAIDSTONE IN 1920. Note the primitive cooking facilities. Luxuries such as wash-houses were the exception rather than the rule.

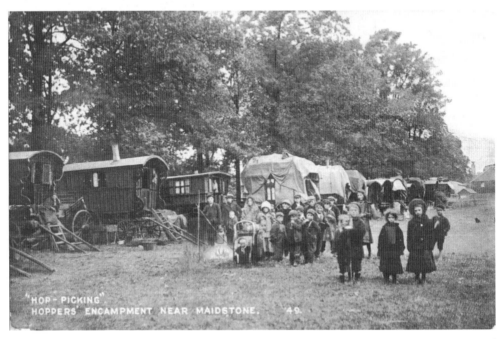

A HOPPERS' GYPSY ENCAMPMENT NEAR MAIDSTONE in 1905. Hopping was just one of the regular seasonal occupations of the gypsies.

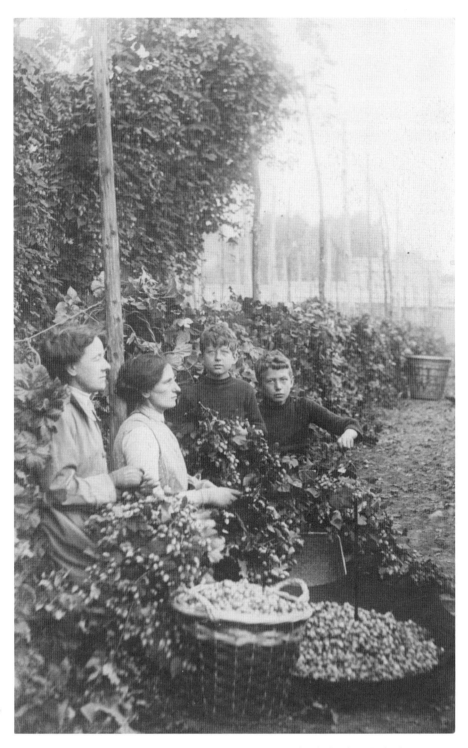

LOCAL FARM WORKERS' WIVES AND FAMILIES also helped with the hops. Note the upturned umbrella utilised as an extra bin.

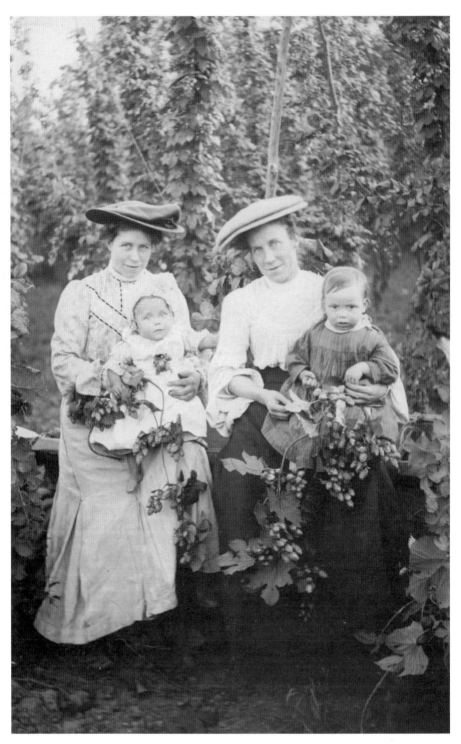

THESE TWO ELEGANTLY DRESSED LADIES with their babies look out of place in the hop gardens of 1908.

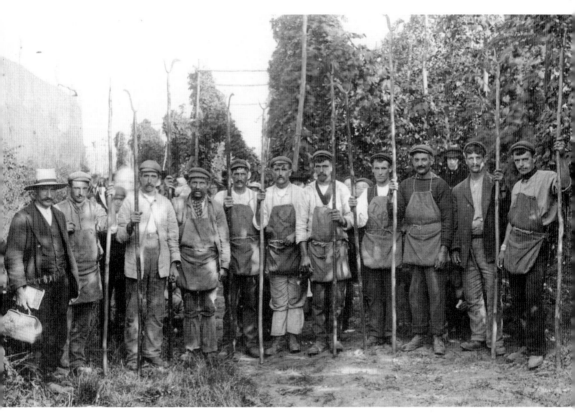

A CREW OF BINMEN ON A FARM NEAR MAIDSTONE in 1910. Binmen or pole-pullers supervised the pickers, assisted the measurer and acted as spokesmen. They were held in some awe by the children they kept in order.

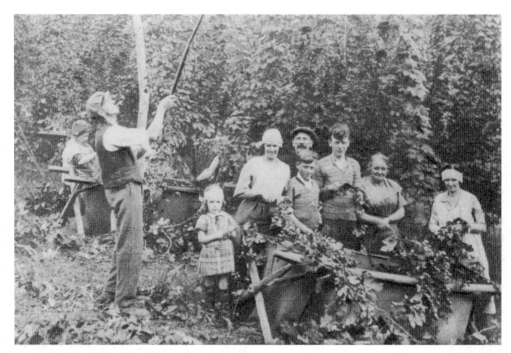

THIS 1930 PHOTOGRAPH SHOWS LONDONERS with a typical bin (a cradle of sacking stretched on wooden supports), as used in Maidstone hop gardens for more than 200 years.

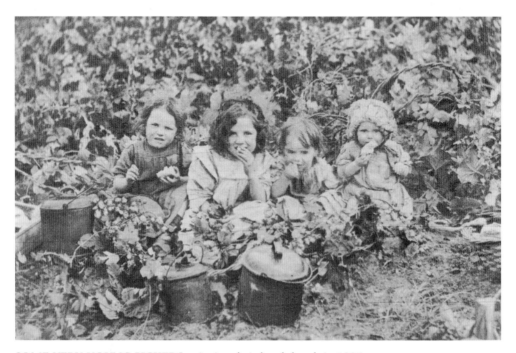

SOME VERY YOUNG PICKERS enjoying their lunch break in 1925.

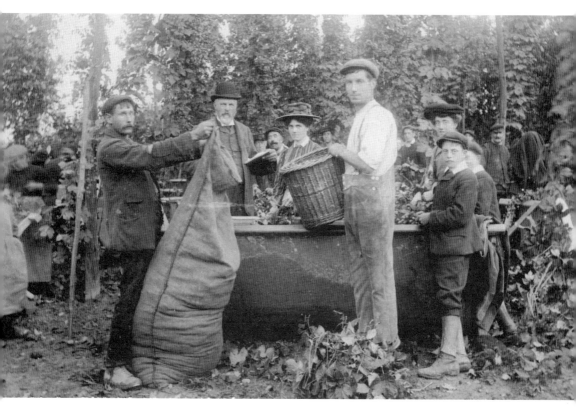

THE BOOKER RECORDING THE NUMBER OF BUSHELS AND HOPS picked by the pickers.
The hops were measured in bushel baskets, then tipped into ten-bushel hop pokes.

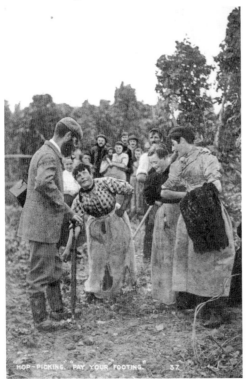

A TALLYMAN ACCOMPANIED BY THE MEASURER in a Maidstone hop garden in 1904. The tallyman kept his accounts by cutting notches in tally sticks. This was one of the earliest means of recording the number of bushels of hops picked by a picker. Tally sticks were gradually replaced by hop tokens, then by cards and a register.

WHENEVER A VISITOR ENTERED THE HOP GARDENS a cry of 'Pay your footing' went up. This was an old hop garden custom in Kent where pickers would hurry to brush the visitor's shoes with hops to exact a fee towards the cost of the traditional end-of-season hop supper. Anyone who refused payment was usually up-ended into a bin full of hops.

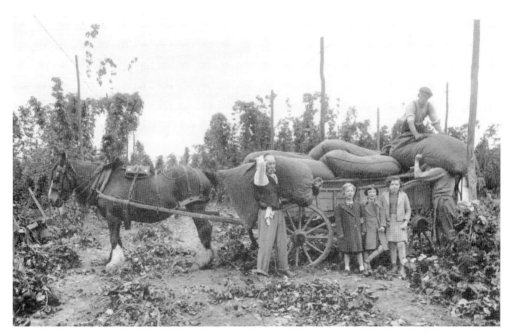

WAGONERS LOADING THE POKES FOR THE OAST HOUSE *c.* 1930. In this case a single horse was able to pull the load.

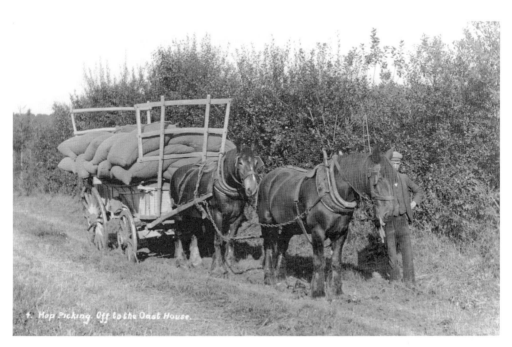

TWO HORSES WERE NEEDED to take this load to the oast, probably because of the rough state of the ground.

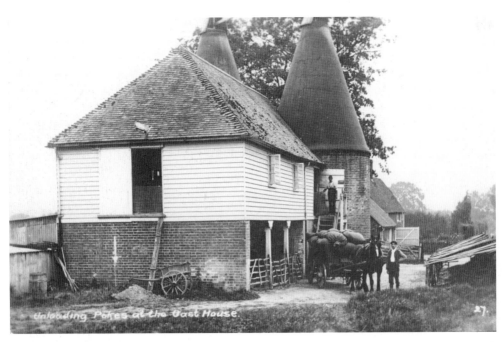

AT THE OAST HOUSE, the pokes were unloaded and carried inside in readiness for drying the hops.

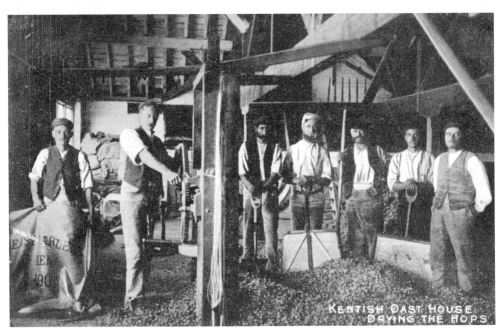

DRYING THE HOPS inside an oast house at East Farleigh in 1906. The process of drying carried on right through the hop season and the dryers only slept for an hour or two at a time, usually on a rough wooden bench in the oast house.

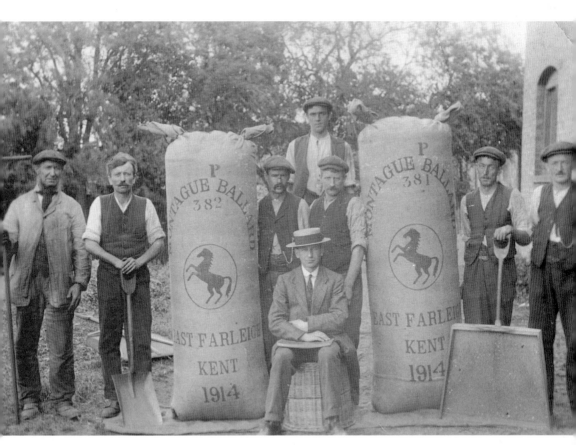

ONCE DRIED, THE HOPS WERE RAMMED INTO POCKETS, each holding about 125lbs. The pockets were marked with the year and the name and locality of the grower. This illustration of the work-force at Montague Ballard's farm at East Farleigh, taken in 1914, shows two pockets ready for the market. Note the large hop shovel or scuppet, made by stitching sacking on to a wooden frame. These lightweight shovels were used so as not to damage the fragile hops.

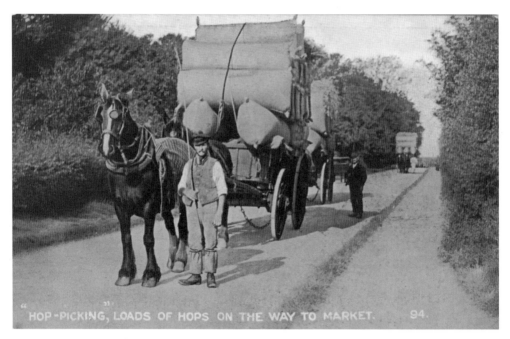

THE POCKETS WERE THEN LOADED ON TO WAGONS and transported to market or the railway station.

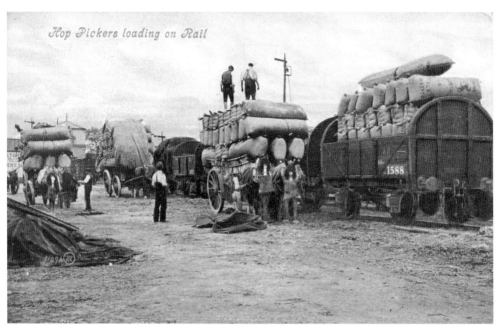

POCKETS OF HOPS BEING LOADED ON TO RAILWAY TRUCKS for the London Hop Market in 1908.

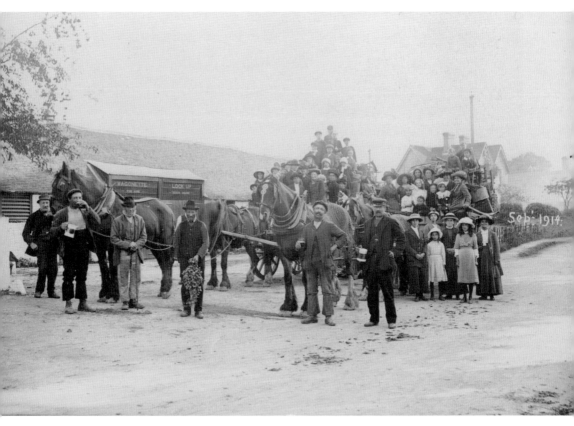

HOP-PICKING OVER FOR ANOTHER YEAR, the pickers, with their belongings, returned to the station in the same carts that carried the hops to the oast. Most of the pickers went home in new clothes purchased from their earnings; their old clothing was often discarded on the streets of Maidstone after the end-of-season shopping spree.

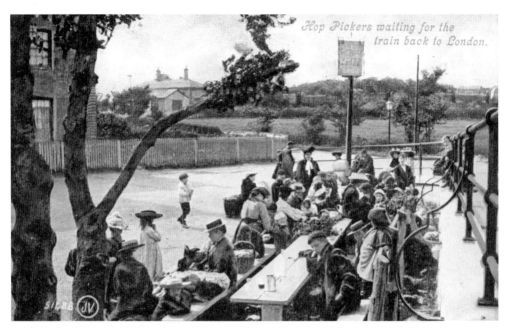

HOP-PICKERS WAITING IN THE RAILWAY INN YARD at Wateringbury for the train back to London.

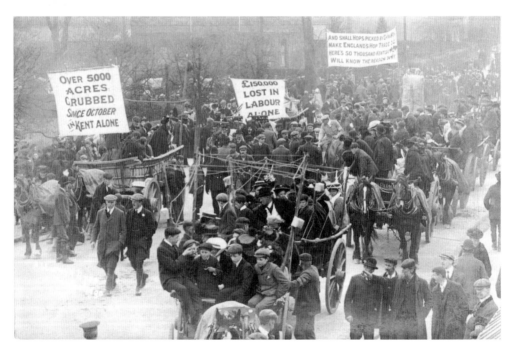

A DEMONSTRATION BY LOCAL GROWERS against the import of foreign hops in 1908. Carts carrying measures of hops draped in black crepe were driven through the streets of Maidstone, Tonbridge and London.

The Environs

Maidstone is surrounded by some of England's most picturesque countryside, famous for its blossom and fruit as well as its hops and oast houses. The villages are rich in interesting churches, timbered houses and quaint old inns. The district is also liberally endowed with castles, ancient buildings and notable relics of prehistoric times.

In the close vicinity are the castles of Leeds and Allington and at Leybourne is the ruined castle of Roger de Leybourne, the Crusader, who died in 1271.

There are fine medieval bridges at East Farleigh, Aylesford and Teston, while Barming still has a wooden bridge across the Medway.

At West Malling is a great Norman tower built by Bishop Gundolph in the eleventh century, and Lenham is noted for a much more modern landmark, a 100 ft white cross cut in the chalk of the North Downs.

The photographs in this section are of just a few of the villages which surround Maidstone; to do full justice to the subject would require a volume devoted entirely to the village scene.

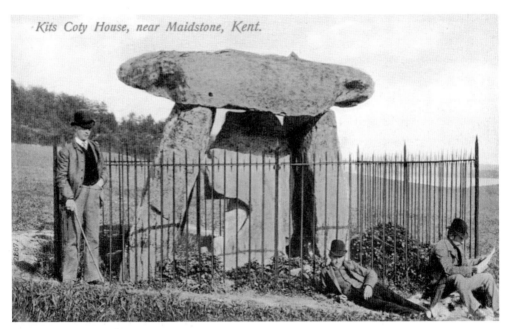

KIT'S COTY HOUSE on Bluebell Hill, Aylesford, photographed in 1910. In 1880 the cromlech was placed under government control by the landowner, Henry Brassey, of Preston Hall.

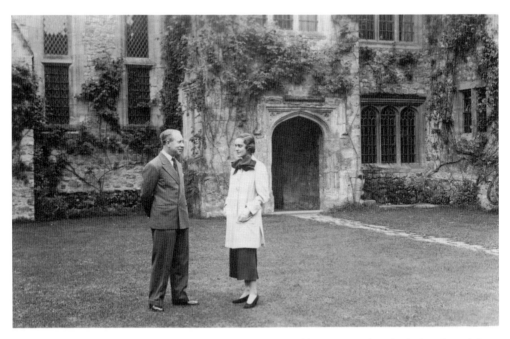

ALFRED C. BOSSOM MP AND HIS WIFE in 1937 at Allington Castle, which they leased from Agnes Horsfield. Agnes inherited the castle from her father, Lord Conway, who had spent thirty years restoring the property. After her death in 1951 the castle was purchased by the Carmelite Order from Aylesford Priory.

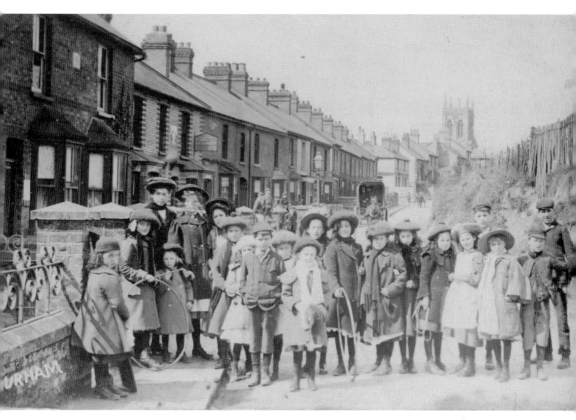

YOUNGSTERS FROM THE VILLAGE SCHOOL AT BURHAM, pictured *c.* 1905. Evidently it was the season for hoops and skipping ropes. The nineteenth-century church of St Mary, in the background, was demolished in 1983.

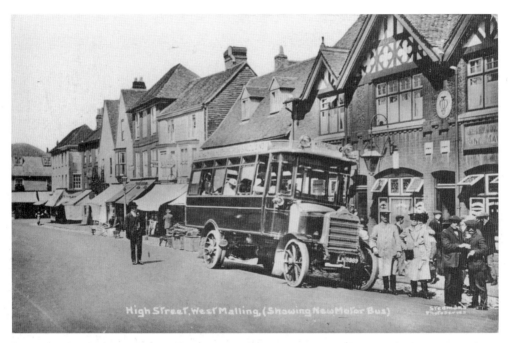

THE NEW CHATHAM TO WEST MALLING DAIMLER BUS, photographed in 1914 in front of the George Hotel in West Malling High Street.

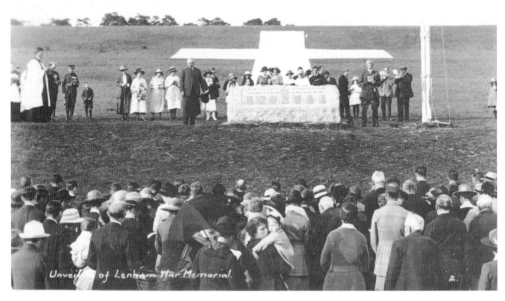

THE UNVEILING OF LENHAM WAR MEMORIAL on the North Downs on 7 September 1922. The 100 ft white cross, cut in the chalk, still remains but the memorial stone was removed to St Mary's Churchyard, Lenham, in 1960.

A GIFT SALE IN LENHAM SQUARE in March 1921. Villagers gave over 300 gifts to be auctioned for the West Kent Hospital Extension Fund. Among the gifts which were auctioned was a buff cockerel which was bought and resold fifteen times, realizing a total sum of £8 15s. Messrs Ambrose & Foster and Mr Harry Judge were the auctioneers and over £250 was raised towards the Hospital Fund.

THE POST OFFICE AND BULL INN, Tonbridge Road, Barming, in 1908. Pocock's bakers cart from Maidstone stands in front of the inn. The post office is now on the opposite side of Tonbridge Road.

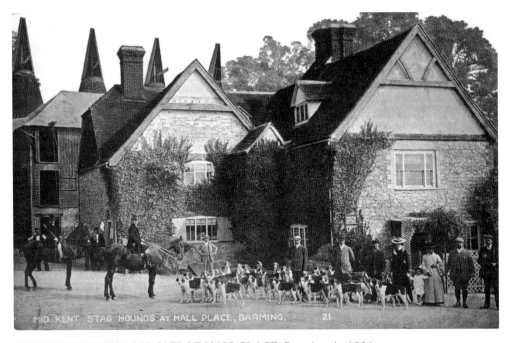

THE HUNT MEETS IN FRONT OF HALL PLACE, Barming, in 1904.

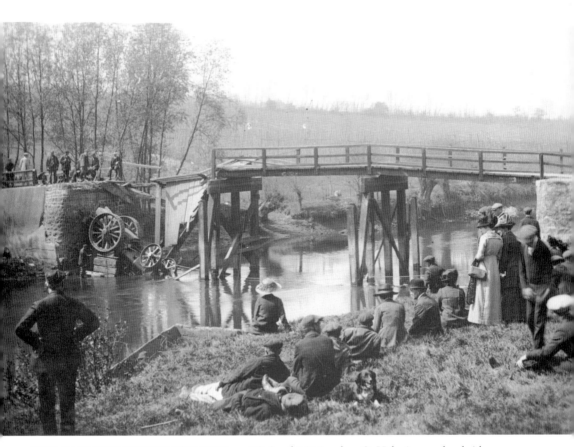

THE BARMING BRIDGE DISASTER on 29 April 1914, when St Helen's wooden bridge gave way under the weight of a 10 ton traction engine, depositing it, with the driver and his mate, into the Medway. Neither man was seriously hurt and the engine was hauled out of the river the following day.

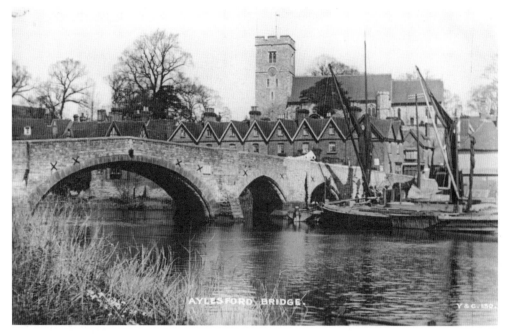

AYLESFORD BRIDGE AND ST PETER'S CHURCH, in 1910. Originally the bridge had six arches, but in 1824 the two centre arches were rebuilt into one large span to improve river navigation. The church contains the tomb of Sir Thomas Culpeper, and the clock on the Norman tower is from the Culpeper's old mansion, Preston Hall.

THE TRANQUILITY OF AYLESFORD VILLAGE in the 1920s.

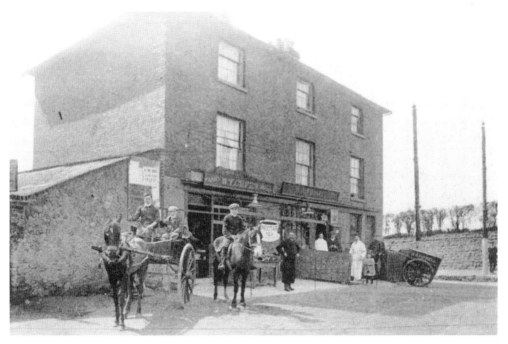

THE SHOPS AT THE TRAM TERMINUS, LOOSE, in 1909. The Stores, belonging to H.A. Funnell, sold groceries, confectionery and tobacco. William Creed was the family butcher.

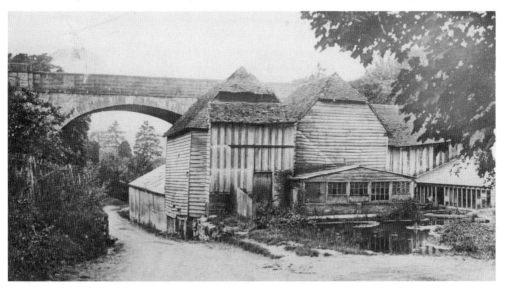

LOOSE VIADUCT (built during the Napoleonic war to aid the movement of troops) and the remains of Gurney's Mill, Salts Lane, photographed in 1916. The mill, which dated back to at least the seventeenth century, was another of the thirteen mills powered by the Loose Stream. Archie and Joe Gurney started to manufacture roofing boards at the mill in 1910 but the venture was not a success and by 1913 the mill had closed. The chimney was demolished in 1914 so that the mill would not provide a landmark for German aircraft.

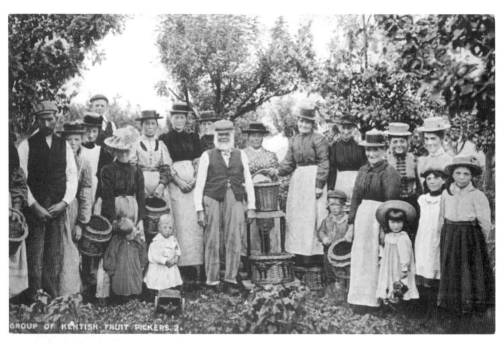

CHERRY-PICKERS ON A FARM NEAR MAIDSTONE in 1904.

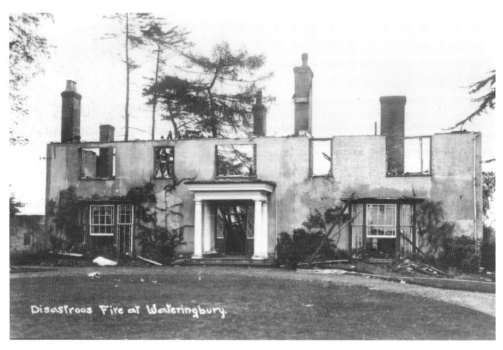

THE REMAINS OF WATERINGBURY HALL, WATERINGBURY, after a disastrous fire on 7 October 1927. The fire resulted in the death of the Bazeley-White family and their nurse. There is a monument to this tragic event in Mereworth Church.

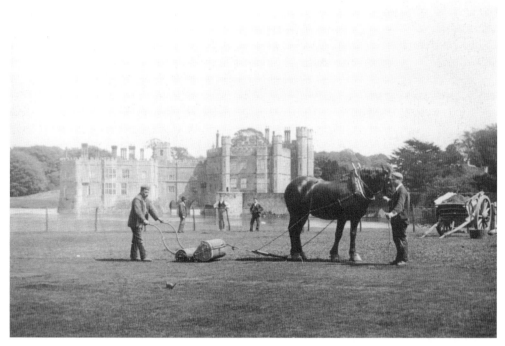

MOWING THE GRASS BY HORSE POWER AT LEEDS CASTLE, *c.* 1904. The horses are wearing overshoes to prevent their hooves from marking the turf.

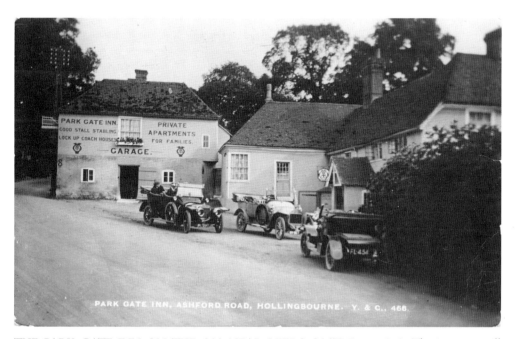

THE PARK GATE INN ON THE A20 NEAR LEEDS CASTLE, *c.* 1918. The inn was still advertising good stabling and lockup coach houses although the motor age had arrived.

ACKNOWLEDGEMENTS

Most of the illustrations in this book are from picture postcards and photographs in my own collection, but I would like to thank the following people and organizations who have kindly loaned me material or given permission to reproduce photographs to complete this project:

Kay and Eric Baldock • B.A. Ball • C. Beale • Stan Bowls • Mrs J. Carter • Courage Ltd.• Drake & Fletcher Ltd.• Raymond Fricker, Maidstone Hospitals Historical Society • Richard Lewis, Photographic Officer, M & D & East Kent Bus Club • M. Lilly • K. Loveland • Mrs D. Marsh • The Editor of the *Kent Messenger* • Henry Middleton (Curator) and Richard Stutely, of Maidstone Museum • Arthur Monk • Dorothy and Stuart Murray • John Philps • Rootes (Maidstone) Ltd. • Trebor Ltd.

I am indebted to the staff of Maidstone Reference Library, St Faith's Street, and the Local Studies Section at Springfield Library, for the assistance which they have given in suggesting and locating sources of information.

I also wish to acknowledge the many books and newspapers I have consulted for historic information, especially *The History of Maidstone* by J. M. Russell, *The Topography of Maidstone and its Environs*, *The Maidstone Official Charter Brochure*, the *Kent Messenger*, the *Borough of Maidstone Official Guide* by L. R. A. Grove and *Kelly's Directories of Maidstone*.

Finally, my thanks are due to Kim Frazer and Kay and Eric Baldock for their assistance in checking captions and to my husband, Tom, for photographing the borrowed illustrations where necessary and for typing the manuscript.